BIBLIODYSSEY

First published in 2007

Murray & Sorrell FUEL ©
Design & Publishing
33 Fournier Street
London E1 6QE

www.fuel-design.com

Printed in Hong Kong

Distributed by Thames & Hudson / D.A.P.
ISBN 978-0-9550061-6-6

BibliOdyssey

BY PK

ARCHIVAL IMAGES FROM THE INTERNET

FUEL

BibliOdyssey is a visual weblog of rare book illustrations, graphic art, illuminated manuscripts, lithographs and Renaissance prints, gathered from across the internet.

In general, individual entries focus on a specific book, illustrator or motif. The images are accompanied by written background and links to the source material and further information. The unifying theme – visual *materia obscura* – was a phrase plucked from the ether as I hastily sketched out the intent of the site when it began two years ago. It remains more a directional aspiration than a concrete rule.

After parachuting out of a workaday job, I landed in Hanoi and environs for a couple of years of cultural immersion and occasional English teaching. While there, I began using the internet more regularly and participating in a community website called Metafilter. Metafilter members post and discuss links on every conceivable subject, from the latest technologies to ancient history, linguistics, pop culture and beyond. Finding stimulating links to contribute was a catalyst to go exploring, and by natural disposition I gravitated towards the more institutional and academic sites.

While browsing the digital labyrinths of national and university libraries I became enchanted by the myriad book illustrations available, and I thought it would be a fascinating subject to pursue on my own site. I really didn't expect that it would last more than a few months. In retrospect, I feel very fortunate that in those early days I received positive feedback in emails and comments on the BibliOdyssey site, and indirectly, on other websites. This gave me the confidence to persevere with the venture. Since then, there have been hundreds more contacts from all over the world. Illustrators, librarians, historians, bibliophiles, archivists, bloggers, publishers, educators and regular visitors have kindly offered background information, translational help, tips about potential repositories, speculative analysis, personal stories, many, many images and general encouragement. It's fair to say that what began as a sincere interest has over time matured into a passionate obsession.

I was very naïve when the site started. I knew next to nothing about the technical aspects of digital image quality and manipulation, and not much more about art, illustration or book history. Early entries were haphazard and tentative; I was simply clipping images from repositories without an overall frame of reference. The development of the site from casual and unsophisticated beginnings to its later visual magazine style is a reflection of my own broadening education in technical and artistic terms. Common sense and experience helped establish some standards in my mind about the optimal image size, format and resolution required. I learned to do very minimal adjustment to the images, with just occasional artefact removal or a little tweaking of the colour balance and simple cropping to highlight details. By necessity I've had to do a lot of background research and reading. My knowledge about general history and the history of prints, book art and science has increased profoundly. But I certainly don't regard any of what I do as particularly unique or special; I think it's more akin to doing a public apprenticeship as a web curator.

Finding post-worthy material for the weblog is largely a labour of randomised logical browsing mixed with capricious taste. While the internet is unquestionably an amazing phenomenon and search engines are powerful navigators, when it comes to obscure book illustrations and prints, unless you already know about the author or title, there is just no easy way to turn up delectable morsels of visual *esoterica*, save for scanning the inventory of relevant sites. So I devote a lot of time to sweeping digital libraries, cultural archives, print galleries, simpatico weblogs, social bookmarking sites, and in following up a selection of noticeboard and email group messages and automatic searches that are delivered to my desktop. To this mix I regularly perform more random searches – with terms like 'etchings', 'prints', 'rare book' and so on – in a number of languages, using regular and blog specific search engines. But this is just the tip of the iceberg. The practical reality of successful web exploration for images is more erratically complex than can be easily described in a step by step fashion, and it is always accompanied by a large slice of luck. The serendipity of discovery is itself a satisfying reward.

During these fishing expeditions, I'm initially looking for related images in sufficient numbers in a digitised book or an exhibition site that will make up a blog post. Then it becomes a matter of judging the image quality, the aesthetics of the artistry and the nature of the subject matter to decide whether or not the series is worth pursuing. Like everybody, I have a broad potential for visual appreciation, and it might well depend on the day and my mood as to how I respond to the material. I can be attracted to pictures that are bizarre or elegant or ingenious or humorous in a general sense, but I'm just as likely to have my interest piqued by the minutiæ.

My attention is frequently drawn to the degree of detail in an engraving, or the exquisite beauty of a particular colour in a manuscript miniature, or a puzzling allegorical motif, for instance. All of these considerations are balanced against what I've seen or posted about previously, and where they fit into a wider historical or artistic context. I might observe technical virtuosity in an image but not pursue the artist or book because it's repetitive or copied, or there are better examples of the same general subject matter elsewhere. Similarly, if a site has cumbersome or restrictive architecture making browsing or image retrieval onerous, I'm just as likely to bypass otherwise desirable images.

Frequently I stumble across single images not in a series, that take my breath away for any of the reasons mentioned. I hoard them, sometimes for many months, hoping to find further examples of a similar flavour, or by the same illustrator, to make up a cohesive entry for the site. When the searching proves fruitless or the computer becomes cluttered, these orphans are gathered together in sporadic, themeless posts. But whether in series or alone, I think that enigmatic illustrations can tempt an observer into wanting to know more about the subject matter. This is particularly relevant on the internet, which tends to cultivate a shortened attention span and favours an image over text mindset. It has never been my intention to masquerade as an educator but I'm casually optimistic that by presenting images and a little context, some people will occasionally experience the same enthusiasm I feel, and want to go digging further into the background themselves.

If dredging up eclectic illustrations from the internet to post on a humble website seems at all like a convoluted process, it pales in comparison to the year long delicate evolution of the book from genesis to publication. All the images in these pages are derived from the internet. Most, but not all, of the illustrations are copyright free. We took the view from the beginning that beyond the obvious aim of wanting to produce a book filled with amazing pictures, we also hoped to draw attention to some of the wonderful libraries and archives that scan and host the images, upon which this book and the website rely.

In announcing our plans to the hosting facilities and formally seeking permission to use their digital files, we were heartened to receive not only cooperation and encouragement, but in some cases direct assistance – such as higher resolution images and access to material and information not directly available to the public. However, any rights we obtained only apply to the appearance of the illustrations in this book and are not transferrable. The question of rights pertaining to digitised or photographed artistic works is the subject of an ongoing, wider debate. While we who are responsible for this book may have individual opinions, it would have been cavalier at best to attempt to invoke localised legal precedents in dealing with repositories from a range of countries. On our particular battlefield, communication and cooperation were judged to be the discretionary tactics of choice to pave the way to a favourable outcome.

No claim as an authority is made with respect to the commentary throughout this book but, suffice it to say that I did a lot of reading and went to great lengths at times in the hope of ensuring accuracy and balance. We did toy with the idea of including a list of websites where further information could be obtained, but beyond providing the addresses for the web page or parent site of origin for the images in the book, having additional links seemed superfluous. You can't click on an internet address in a book, and websites frequently change locations or are removed altogether. All the keywords are here and can be easily used in search engines. The only person I really plagiarised was myself, but it was only once, and it was simply because I didn't think I could improve upon a particular entry I wrote long ago on the BibliOdyssey website.

At the time of writing, while the centrifuge of visual obscurity is still spinning the constituent parts down to its final form, I can't quite recall how many of the images in the book have appeared on the website, but I suspect it is around sixty percent. Ultimately, I envisage a threefold purpose in compiling a book of diverse illustrations – the simple pleasure of eye candy; the evocation of a deeper interest in an historical, artistic or scientific subject; and for use as a projectile, to be thrown at those who would say there is nothing worthwhile to be found on the internet, or who question why anybody would want to spend so much time in front of a computer screen.

PK

Sydney
July 2007
– – –
http://bibliodyssey.blogspot.com

Pl XXV

FOREWORD

Dinos Chapman

– – –

To whom it may concern,

The Marriage of Reason and Squalor... again.

Whilst thanking you for inviting me to contribute a foreword for your book, clearly a splendid effort, I feel compelled to voice a forewarning regarding the internet, which is at least partly its subject. It is a treacherous minefield to be trodden with trepidation if it is to be used for anything other than a prurient delve into the seamier side of human frailty. And whilst I am unsure as to whether it is as yet of sufficient age to contain any really dusty corners, it certainly does have innumerable less than spotless ones.

At present widely (though I fear misguidedly) perceived as the fountain of all knowledge, a veritable Library of Alexandria, the internet would be better compared to the Tower of Babel, in its confusions, inaccuracies misdirections and meanderings, a largely abused resource, as with many other contemporary technological innovations, infected with the malaise of over-familiarity fused with idiocy.

Visions of a techno-nirvana, glimpsed at the conception of the information age by goggle-eyed prematurely balding, pale-skinned computer technologists schooled in unattainable utopian idealism, that promised a Brave New World, an informational arcadia, vibrant with abundant, free flowing knowledge, liberated from location and ownership, an all-encompassing forum for all wisdom, of course rapidly degenerated to a grotesque charade. Its birth fumbled, the baby dropped on its head, a drooling rheumy-eyed imbecile, blinking in the harsh Californian sunlight, all expectations dashed, potential squandered. The dream evaporated, the promised land a mirage, receding rapidly over the shimmering horizon.

Information was not going to free the world any time soon, but neither was it going to propel it into a Matrixesque dystopia, the threat that personal computers allied to a global network once presented to the governments of the Free World, (apparent missile-launching capabilities, dissemination of radical politics, sensitive information hacking, the rise of the robots...) appears to have been overstated, a damp squib, the stuff of paranoid science fiction. The emergent usage of this futuristic technology is altogether more prosaic, in time honoured tradition, it has been dragged down to its lowest common denominator, a labour-saving device of the most crass order: a less than useless tool for ordering cold inedible pizza from around the corner, a plain cover wrapper for pornography, the discrete purchase of Viagra, the sending of virtual birthday cards... As the spectre of power in the hands of the masses dwindled, the sighs of relief were all too clearly audible.

Adept at crashing around on the World Wide Web with all the finesse of a class of demented five-year-olds at milk break, simultaneously unable and unwilling to concentrate on anything for longer than it takes to click on the 'next image' button, we are mesmerised by the box that the internet was delivered in, happy to squat in it and pretend. We would be just as content with a Fisher-Price designed internet with nice rounded corners and just one big red button, labelled 'entertain me'. Even its terminology is infantile: cookies, Google, wizards, blogs, lull us into a false sense of security, this is a friendly place, nothing bad here.

Yet this global village, an insignificant and squalid burg, has us hypnotised with the cheap flickering lights, slick graphics and gaudy colours of its sleazy infotainment grotto, global village idiots, blinkered and dribbling, we gleefully hobble on atrophied legs (in lieu of a healthy walk to the local library, and in an effort to minimize our carbon footprint, how about computers powered by treadmill...) along the well trod malodorous mire spattered single track information superhighway, that terminates at Google, that vast gaping midden of febrile enterprise and misguided attention, the final triumph of squalor over reason. An End of Days super jumble sale of interminable collections of feeblemindedness: strangers' holiday snaps, their comical dogs/cats/goldfish, collections of amusing misshapen vegetables that resemble penises, misshapen penises that look like vegetables, garden furniture mishaps, cute babies, ugly babies, an exhaustive study of every gurn ever performed by a baby, babies with too many/not enough heads..., milfs, camel-toes, spring-breaks, nipple-slips,

happy-slaps, train wrecks, pissed mates, ex-girlfriends, dog fights, cat fights, freaks, faeces, faces of death, beheadings, on and on ad nauseam. There, nightly to immerse ourselves up to our armpits (over our heads) in filth and detritus, to savour nuggets of inanity, (the television cannot compete anymore, has had its day, given up the ghost). And so to bed, to emerge blinking, Morlock-like, maggot pale, slick with sweat, debilitated by fever dreams colonised by digital succubi, into a grey, dull and dreary hollow reality.

A globe spanning monument to the pratfall, the elevation of 'You've Been Framed' to an international interdenominational hyper-church, that holds us in its thrall, endlessly confirming our mawkish addiction to bargain basement entertainment, proof that we are indeed God's little joke, cavorting in ever decreasing spastic circles, until we collapse in floods of tears like overwrought toddlers playing musical chairs, not understanding the rules.

We trade our real existence for an impoverished virtual version, a second life, having failed miserably in our first one, now offered a second chance… Only to repeat all the mistakes, to reinforce all of the stupid preconceptions that got us into this predicament in the first place. Given the opportunity to throw out all the rules and start again (after all it is only make-believe), we build an almost perfect analogue, doomed to play out the same dismal roles under different titles. The virtual communities we build mirror almost exactly the ones we are so desperately trying to evade. We fantasize an escape while entrenching ourselves deeper and deeper.

Trawling the net endlessly, seeking out confirmation of our existence, finding surely irrefutable proof on our websites, MySpaces, YouTubes. Counting our friends (most we will never actually meet) by numbers of hits received on them. Whilst the technology of the global village enables us access to a vast audience, we have nothing to say, nothing to show, so we resort to what we can all do with a certain amount of expertise – to make imbeciles of ourselves. The bigger the fool, the greater the audience. We have submitted so entirely to the cult of celebrity, that we convince ourselves that merely to appear on a remote screen is enough, regardless of whether we are being applauded or mocked. We have forced the technology that promised to make us free, to chain us like a

neglected hound to the back of a truck, obliged to run wherever it goes.

The point of no return, of surrender to futility is surely wayposted by the emergence of Wikipedia, a 'democratic' encyclopedia, that allows, or rather encourages, adjustments and amendments to its entries, as it advertises on its web page: 'the free encyclopaedia that anyone can edit.' That anyone, regardless of their competence can post their modifications, is surely the very reason why nothing on this site should be trusted, which totally negates its purpose, yet it remains a credible source of information, even though it resembles nothing more than a game of Chinese whispers.

The camera pulls out to reveal heaps of reeking debris, stretching from horizon to horizon. We are adrift in an infinite lost property department. We have seen everything, yet we still crave the obscure. Horrors once hidden are now routine. We scrabble even more frantically, searching further afield, addicted to the freak show. Inured to the most extreme images, we plough through them relentlessly, daring ourselves onwards. No longer do we have to press our faces against the newsagents window to sneak a glimpse at the top shelf. Images too raw and brutal for the newspapers are paraded for our amusement, dangled temptingly in front of us, it is all that we can do to avoid them, it is hardly surprising that we happen upon them, with frightening regularity, no matter how sophisticated the safeguards appear, or how hard we try to convince ourselves that we are not curious… And of course, in the words of Marilyn Manson: 'When I said *we* you know I meant *me*…'

So when I have finished squeezing words out of this stubborn machine, even though it is late, and I am exhausted, I shall don my reeking sackcloth and shuffle as usual, down that fetid gaping maw that leads to rotten.com, and join the nightly refrain…

'I cant look, I must look'. Is that…

The Triumph of Cupid
George Cruikshank, 1845

The Table Book is a collection of monthly periodicals
released by George Cruikshank (see page 70) and
published in a single volume by *Punch Magazine* in 1845.
It featured articles by authors such as William Makepeace
Thackeray with steel engravings and woodcut illustrations
by Cruikshank. *The Triumph of Cupid* shows the
meditative illustrator encircled by a mythical procession
of characters he conjures from puffing away on his
meerschaum pipe (at the bottom of the image: *ex fumo
dare lucum* – from smoke, follows light). This self-portrait
homage to his beloved muse – tobacco – has a certain
irony considering that later in life, in his temperance
phase, when both smoking and drinking were renounced,
Cruikshank's illustrative powers were in decline. Logical
fallacies aside, the image remains an absorbing portrayal
of the great illustrator and his fertile imagination.
– – –

COCONINO CLASSICS MUSEUM
http://www.coconino-classics.com

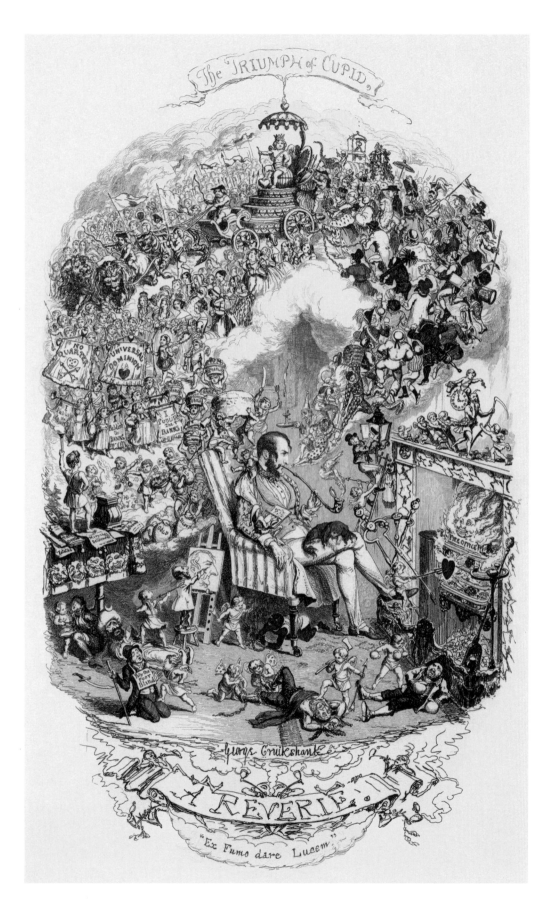

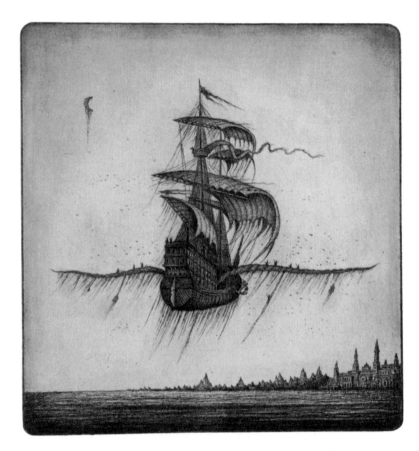

Flying Dutchman
Sergey Tyukanov, 2000

Formally trained as a graphic artist in the far east of
Russia, Sergey Tyukanov combines elements of myth,
folklore and fantasy in his unique etchings and paintings.
– – –

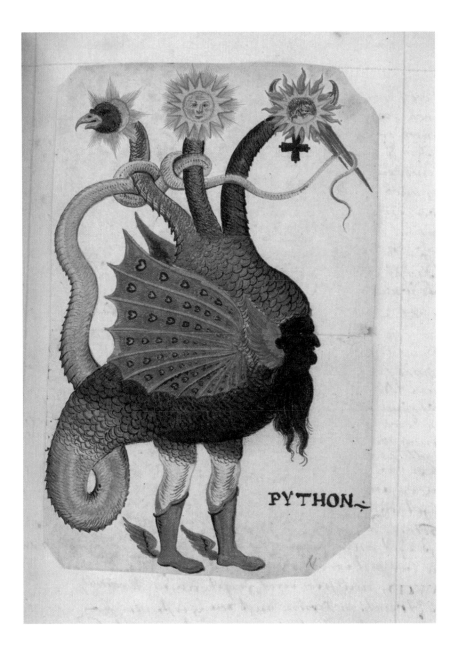

Python (Mercurius as the three-headed dragon)
Giovanni Battista Nazari, 1600

Giovanni Battista Nazari published his intriguing alchemy
text, *Il Metamorfosi Metallico et Humano* (Metallic and
Human Metamorphosis) in 1564, which itself transmuted
into *Tre Sogni Della Tramutatione Metallica* (Three Dreams
on Metallic Transmutation) in subsequent editions. The
dreams refer to visionary journeys made by the narrator in
which he encounters nymphs and monsters in his quest to
find the secrets of alchemy. Nazari borrows from a number
of earlier works as he weaves together a pastiche of styles
ranging from fantasy, fable and scientific text.

– – –

BEINECKE RARE BOOK AND MANUSCRIPT LIBRARY,
YALE UNIVERSITY
http://www.library.yale.edu/beinecke/index.html

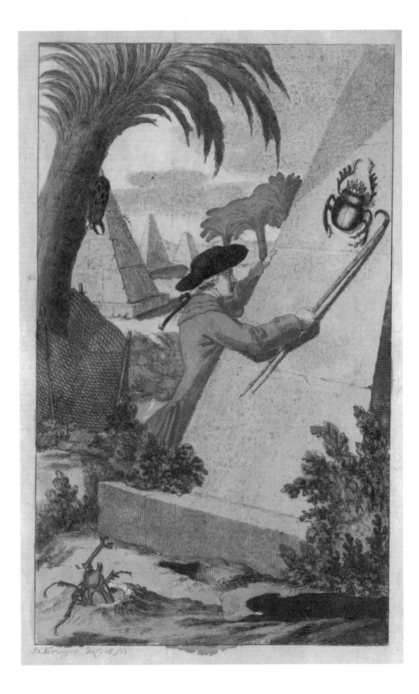

Scarab Beetle
Carl Gustav Jablonsky, 1785-1806

In an audacious move between duties as the secretary to
the Queen of Prussia, German naturalist, Carl Gustav
Jablonsky, attempted to survey the world's largest order of
insects, *Coleoptera* (mostly beetles). His ten volume work,
Natursystem Insecten, was intended to augment Buffon's
massive *Historie Naturelle*. In typical 18th century
artifice, the stylised image shows the beetle on the side

of a pyramid, alerting readers to the scarab's prominent
place in Egyptian mythology.

– – –

DANISH VETERINARY AND AGRICULTURAL LIBRARY,
UNIVERSITY OF COPENHAGEN
http://www.dvjb.kvl.dk

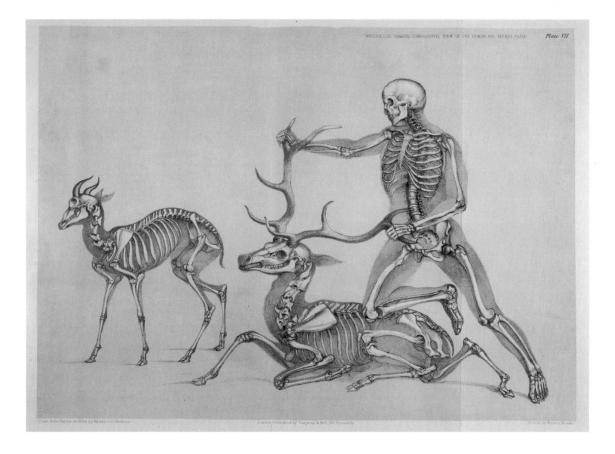

Man, Stag and Antelope
Benjamin Waterhouse Watkins, 1860

Science illustrator and sculptor, Benjamin Waterhouse Watkins, achieved notoriety in the 1840s by constructing the first dinosaur models. His collaboration with famed palaeontologist, Sir Richard Owen, later allowed him free access to the zoological specimens at the museum for the Royal College of Surgeons. In his artistic instruction book, *A Comparative View of the Human and Animal Frame*, Watkins presented a series of plates based on the museum exhibits that were designed to 'to give a comparative view of the variation in form of the bony skeleton or framework of those animals most frequently required by the artist, designer, or ornamentist'.

– – –

HISTORY OF SCIENCE AND TECHNOLOGY COLLECTION,
UNIVERSITY OF WISCONSIN
http://digicoll.library.wisc.edu/HistSciTech

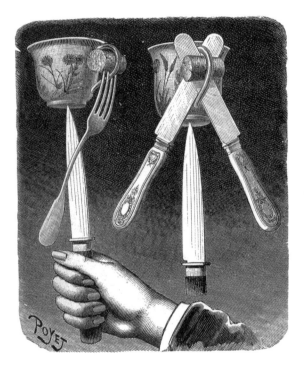

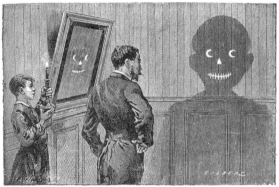

La Science Amusante
Poyet, c.1890

In the late 19th century, the weekly French magazine,
L'Illustration had a column called *La Science Amusante*
in which Tom Tit (pseudonym for Arthur Good) provided
details about experiments and magic tricks that could be
performed by readers. The articles only included items
that could be easily obtained from around the house:
water, eggs, matches, bottles, glasses and the like.
In this way, children could use the principles of chemistry,
physics and magnetism to baffle and intrigue their friends.
The weekly columns were compiled into three very popular
La Science Amusante books, released between 1890 and
1906, which included the original engravings by a prolific
science illustrator known simply as Poyet.

− − −

THE CULTURE ARCHIVE
http://www.fulltable.com

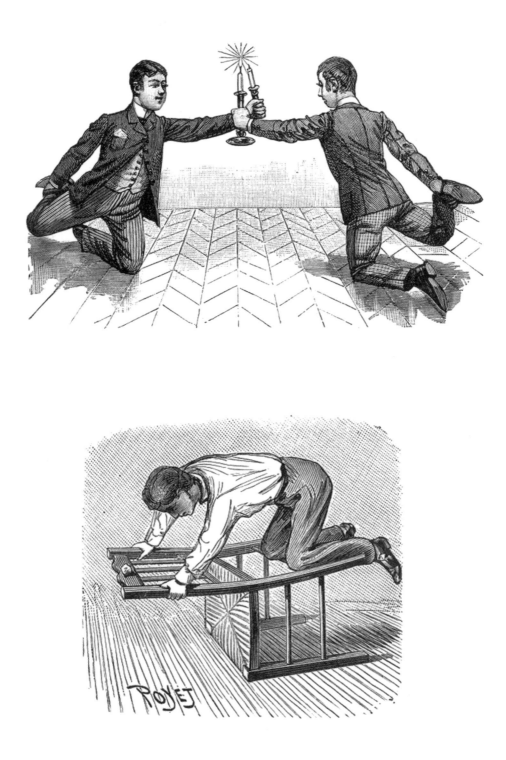

Designs of Chinese Buildings, Furniture, Dresses,
Machines, and Utensils
Sir William Chambers, 1757

In his travels with the Swedish East India Company,
Scottish architect, Sir William Chambers, visited China on
a number of occasions. In 1757 he compiled a book of his
sketches – *Designs of Chinese Buildings, Furniture,*
Dresses, Machines, and Utensils – which had a
significant influence on contemporary European design
style. Chambers drew upon this background when he later
designed the Pagoda for Kew Gardens. The unconventional
design ideas portrayed here are details taken from the
French edition of Chambers' book, *Desseins des Edifices*.

– – –
THE DIGITAL LIBRARY FOR THE DECORATIVE ARTS
AND MATERIAL CULTURE, UNIVERSITY OF WISCONSIN
http://decorativearts.library.wisc.edu

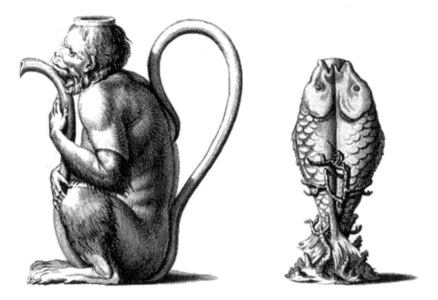

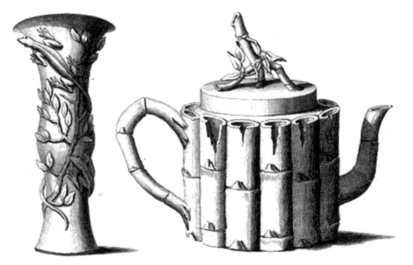

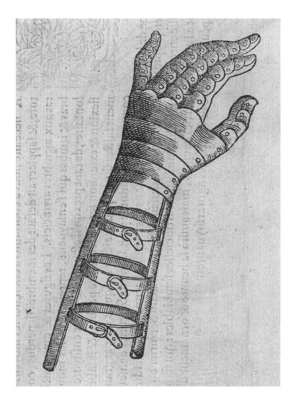

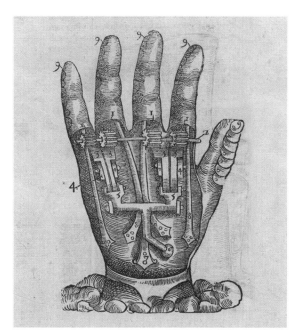

Les Oeuvres d'Ambroise Paré
Ambroise Paré, 1585

Apprenticed as a barber-surgeon at the age of thirteen, Ambroise Paré would become one of the most outstanding surgeons of the Renaissance. He enlisted as a field surgeon in the army where his independent thinking led to extraordinary advances in gunshot wound treatment and surgical amputations. The prosthetic limbs seen here, taken from a 1585 compilation of his works – *Les Oeuvres d'Ambroise Paré* – include engineering features still in use today. Paré would become the official surgeon to a number of French monarchs and he also practiced extensively in the field of obstetrics. This latter work exposed him to many birth defects, a popular subject for 16th century anatomical treatises. He is remembered equally for the pictures of deformed monsters and mythological creatures included in one of his more fanciful books (see overleaf) as he is for the groundbreaking advances he brought to medicine.
– – –

US NATIONAL LIBRARY OF MEDICINE
http://archive.nlm.nih.gov/proj/ttp/paregallery.htm

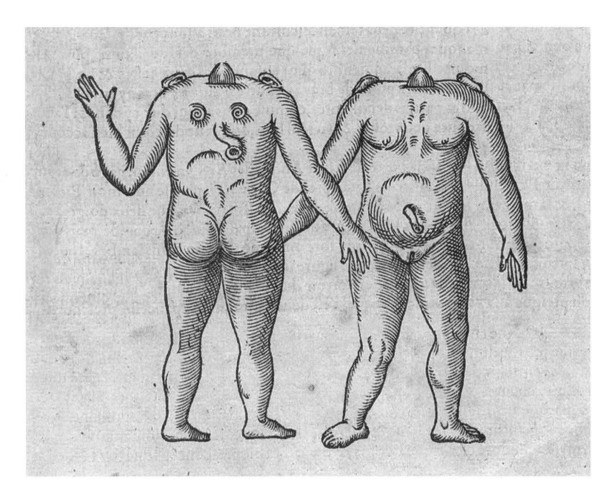

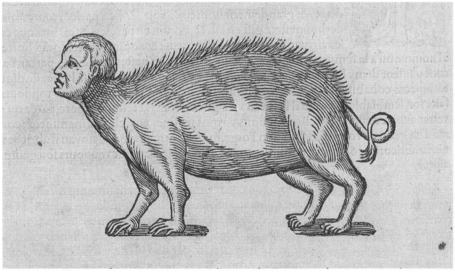

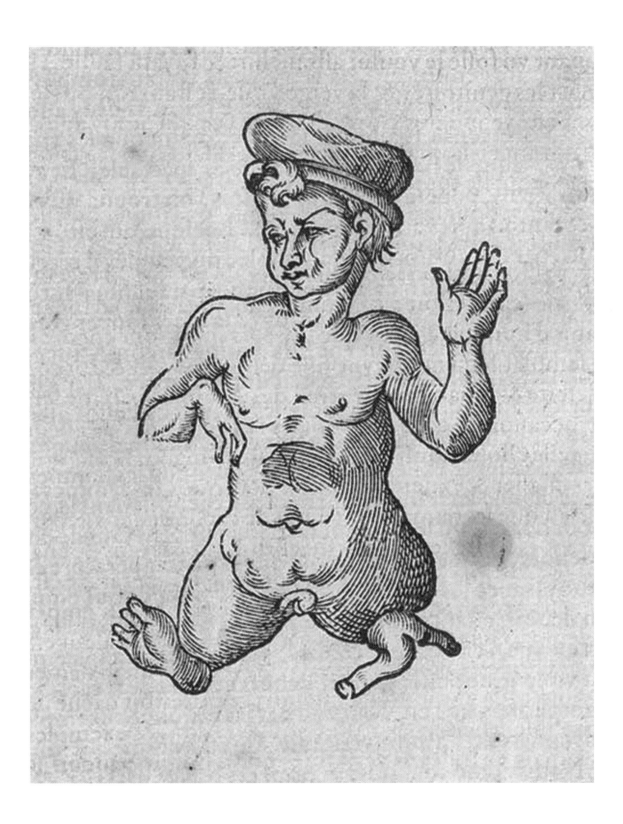

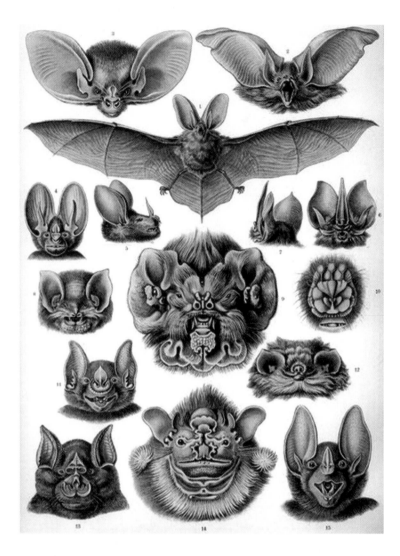

Kunstformen der Natur
Ernst Haeckel, 1904

Zoologist and artist, Ernst Haeckel, was a great admirer of
Goethe, who asserted that the underlying truths of nature
could be revealed through art as well as science. Although
he could lay claim to the discovery of more than 4,000
new species, especially among the microscopic *Radiolaria*,
it was Haeckel's vivid scientific sketches that influenced
the Art Nouveau movement for which he is best
remembered. *Chiroptera* (bats) is possibly a lesser known
illustration from the seminal 1904 book of one hundred
lithographs, *Kunstformen der Natur* (Art Forms of Nature),
but the arrangement of figures is typical of Haeckel's
devotion to symmetry. The Sea Anemone (*Actiniae*) image
is a more typical example of Haeckel's dazzling artistic
style. (see also page 48)

– – –
KURT STÜBER, ONLINE LIBRARY OF BIOLOGICAL BOOKS
http://www.biolib.de

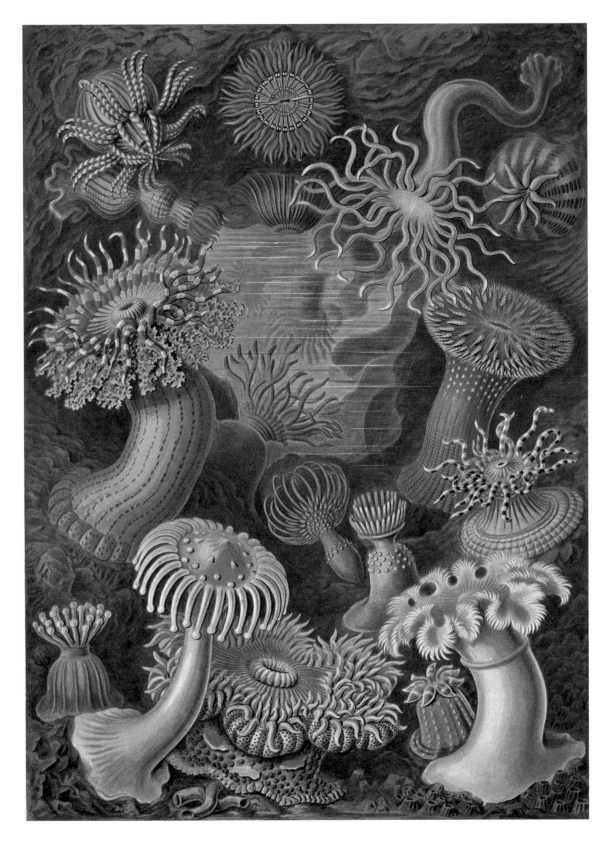

23

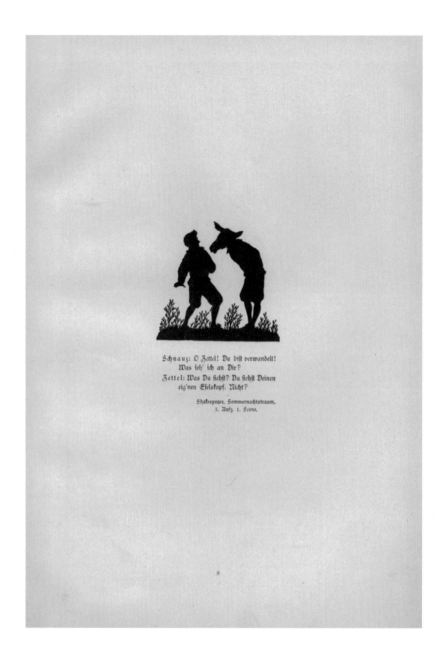

Silhouetten
Anonymous, c.1890

Silhouettes have been found in cave paintings from the Stone Age, ancient Greek vase decorations and in Indonesian shadow puppetry, by way of historical examples. The modern equivalent originates in early 18th century Europe, when aristocrats would hire silhouettists to make paper cut-out portraits of family members and guests. The art grew in popularity as it was a cheap way to have a person's likeness rendered prior to the advent of photography. The name *silhouette* derives from the miserly French finance minister from the 1760s, Étienne de Silhouette, who was known to be fond of doing things cheaply, including making paper cutouts at home.

The populace wore black clothing to mock the unfeeling taxation overlord, going *à la silhouette* in protest. The name, but not the negative connotation, stuck. The image here, accompanied by a snatch of Shakespearian verse in German, comes from a slender anonymous volume of silhouette illustrations from the end of the 19th century. This was a high quality (probably) privately printed children's book listed simply as *Silhouetten*.

– – –

UNIVERSITY OF BRAUNSCHWEIG DIGITAL COLLECTION
http://www.digibib.tu-bs.de

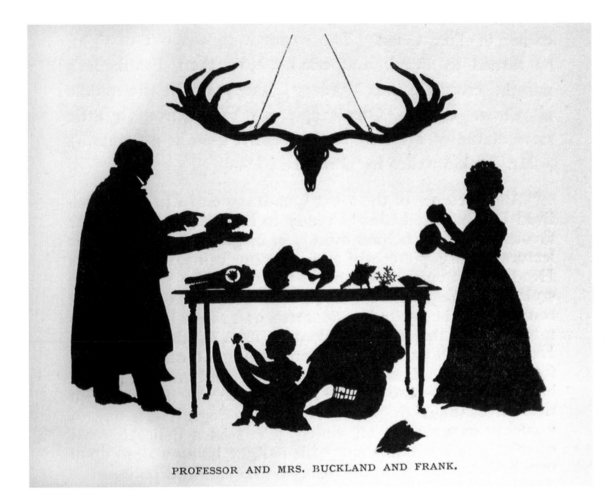

PROFESSOR AND MRS. BUCKLAND AND FRANK.

Professor and Mrs Buckland and Frank
Auguste Edouart, 1828

Renowned silhouettist, Auguste Edouart, produced this 'conversation piece' profile of Oxford University Professor William Buckland's family in 1828. Buckland was a pioneer in the fields of geology and palaeontology and in 1824 provided the first published description of a dinosaur in *Notice on the Megalosaurus* or *Great Fossil Lizard of Stonesfield*. He was also something of an eccentric, given to outlandish dress and behaviour, and he bragged of having eaten his way through the entire animal kingdom. Apparently, his least favourite dishes were prepared from bluebottle and panther. As a result of his many field trips, Buckland's house became something of a museum, accounting for the fossil bones seen in the illustration.

– – –
DEPARTMENT OF THE HISTORY OF SCIENCE,
UNIVERSITY OF OKLAHOMA
http://www.ou.edu/cas/hsci

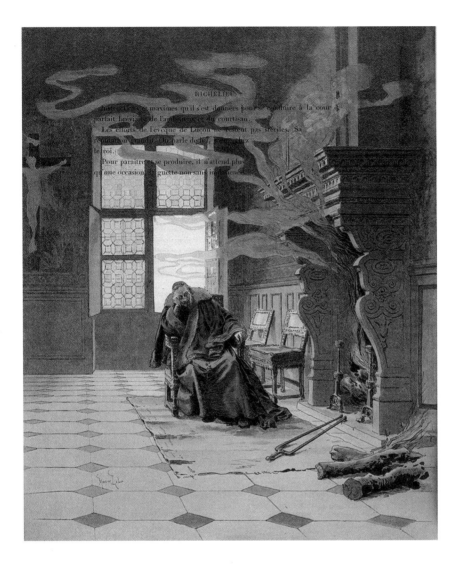

Richelieu
Maurice Leloir, 1901

The career of Maurice Leloir embodies the *fin de siècle* confluence of art, literature, theatre, and cinema. In addition to being president of the Watercolour Society of France, founder and president of the Costume Society, author and illustrator of a *Dictionary of Costume*, theatre stage designer and poster artist, Leloir even had a stint in Hollywood as artistic director for Douglas Fairbanks. He also illustrated a large number of books, including a series of beautiful chromolithographs for a 1901 text by Théodore Cahu about the life of the 17th century French statesman, Cardinal Richelieu (*Richelieu*). Epic period dramas gave Leloir the opportunity to combine his watercolour skills with his intimate knowledge of costume history (he was also an avid collector of costumes and donated 2,000 of them to a Paris museum). In a similar vein, his drawings for *The Three Musketeers* are considered the definitive illustrations for Dumas' classic tale.

– – –

THE CULTURE ARCHIVE
http://www.fulltable.com

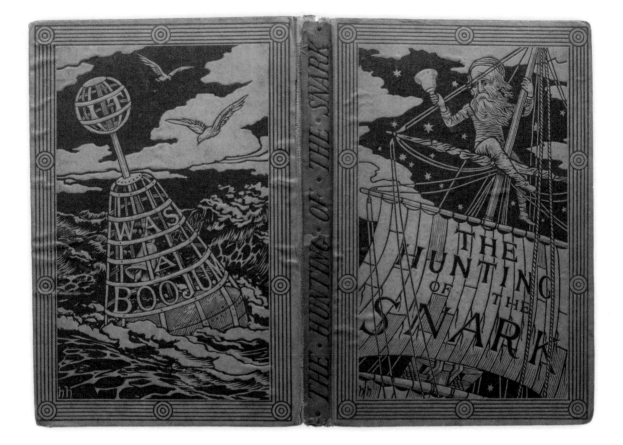

The Hunting of the Snark by Lewis Carroll
Henry Holiday, 1876

Lewis Carroll created a veritable industry of academic enquiry with the publication in 1876 of his metrical poem of nonsense, *The Hunting of the Snark: An Agony in Eight Fits*. The humorous poetry describes a fantasy voyage by an odd crew to find a creature described only by its taste and preposterous habits. Carroll mostly denied that there were deeper meanings, although he did concede it was an allegory for finding happiness. Many and varied interpretations of the poem have been formulated including a compelling argument that relates its shenanigans to Carroll's beloved uncle and a psychiatric board of review on which he sat until his death, the year before the writing of the poem commenced. Stained glass designer Henry Holiday was specifically instructed by Carroll not to attempt to sketch the mysterious snark in his series of somewhat gloomy caricatures that appeared in the first edition. The nine illustrations have themselves greatly contributed to the extensive analysis that has enveloped *The Hunting of the Snark* since its original release.

– – –
OCTAVO CORP AND THE BURSTEIN COLLECTION,
THE RARE BOOK ROOM
http://rarebookroom.org

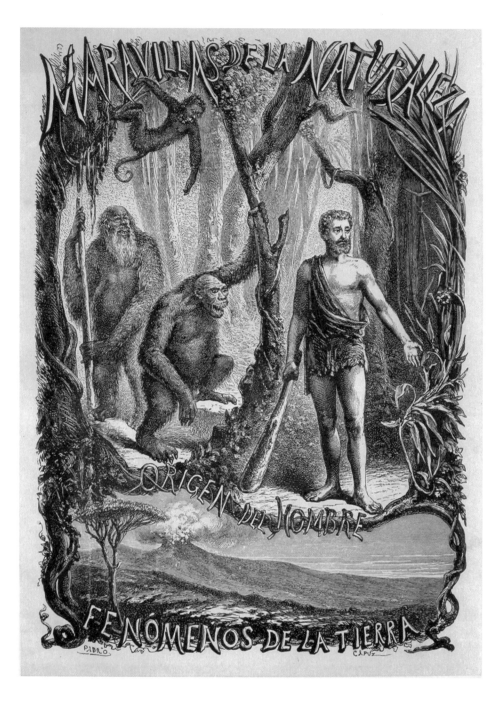

Frontispiece *Maravillas De La Naturaleza Origen Del Hombre Fenómenos De La Tierra*, 1870

Louis Figuier was a prolific writer whose books and magazine articles did much to popularise science in 19th century France. Jules Verne relied upon Figuier's writing for the science content of *Journey to the Centre of the Earth*. The frontispiece above comes from an 1870 Spanish translation of Figuier's *The World Before the Creation of Man – Problems and Wonders of the Natural World*.

– – –

DEPARTMENT OF THE HISTORY OF SCIENCE,
UNIVERSITY OF OKLAHOMA
http://www.ou.edu/cas/hsci

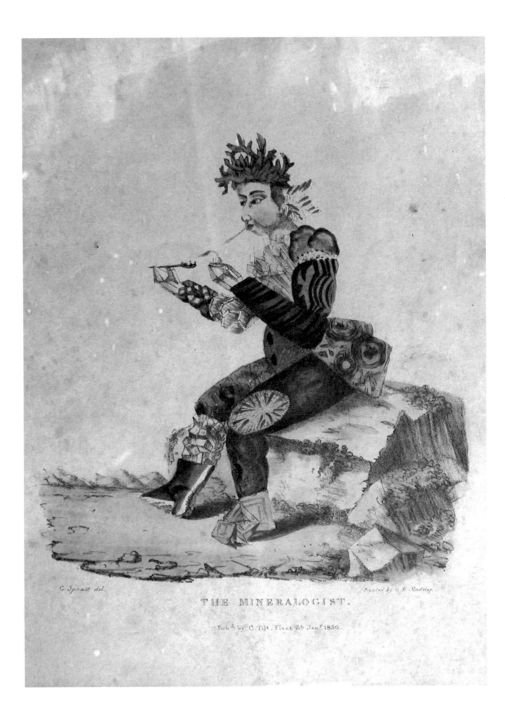

The Mineralogist
G. E. Madeley and G. Spratt, 1830

The visual pun of occupational anthropomorphism has its origins at least as far back as Arcimboldo in the 16th century. There have been a number of print series in which the subject of a portrait is depicted with body parts made from the tools of his trade. The G. E. Madeley and G. Spratt illustration here, with limbs formed from crystals and stones, was part of a humorous set, perhaps lampooning the popular contemporary 'science' of physiognomy.

– – –
DEPARTMENT OF THE HISTORY OF SCIENCE,
UNIVERSITY OF OKLAHOMA
http://www.ou.edu/cas/hsci

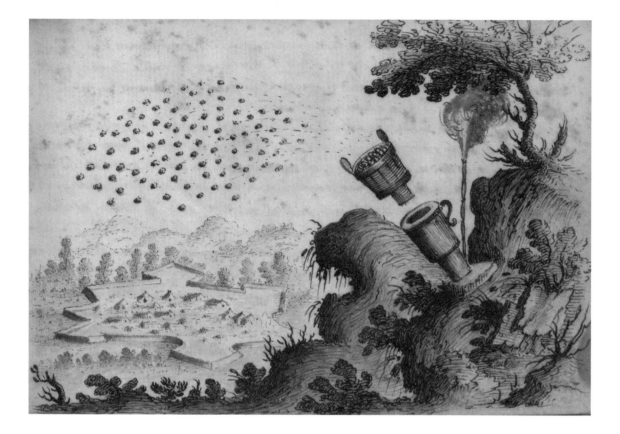

Sketchbook on Military Art
Anonymous, c.1600

This intriguing anonymous codex (Rosenwald 1363) is
thought to be Florentine in origin and contains myriad
fortification, pyrotechnic, geometry, artillery and machine
drawings. The skilled draughtsman and author is probably
associated with the architect and stage designer, Giulio
Parigi, who was an instructor to the nobility at the Court
of Medici.
– – –

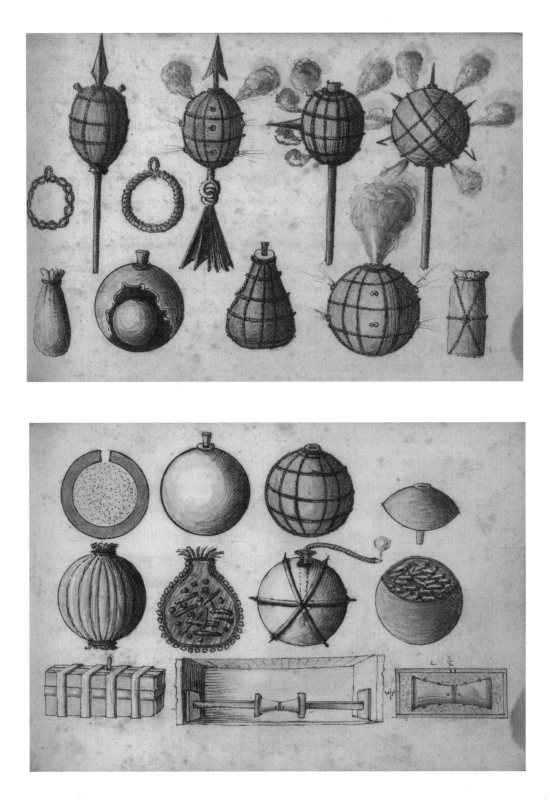

Stultifera Navis by Sebastian Brandt
Albrecht Dürer, 1494

Sebastian Brandt's immensely popular 1494 moralistic satire, *Stultifera Navis* or *Das Narrenschiff* (Ship of Fools), criticizes all manner of human folly and weakness, as an allegorical ship (life) sails towards a fool's paradise. The success of the work is attributed in large part to the humorous woodcut illustrations (most by a young Albrecht Dürer) that accompanied the didactic verse. The images here warn against waiting for an inheritance and the sin of pride.

– – –

UNIVERSITY OF HOUSTON LIBRARIES SPECIAL COLLECTIONS
http://info.lib.uh.edu/sca/index.html

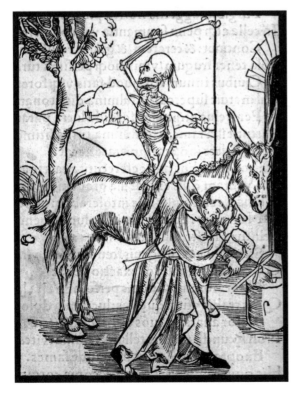

Alte Armatur und Ringkunst
Hans Thalhofer, 1459

Hans Thalhofer from Swabia contributed a number of
Fechtbücher (illustrated combat manuals) to a miscellany
of works on martial arts that were produced in late
Medieval and Renaissance Europe. Arising largely from
13th and 14th century secret teachings, the often
intentionally obscure *fechtbücher* laid out techniques
for fencing, wrestling, jousting and other warring arts.
Thalhofer's 1459 treatise, *Alte Armatur und Ringkunst*
also contained illustrations of clandestine fighting and
infiltration techniques, including underwater breathing
and barricade scaling contraptions.

— — —

DEPARTMENT OF MANUSCRIPTS & RARE BOOKS,
ROYAL AND NATIONAL LIBRARY OF DENMARK
http://www.kb.dk/en/kb/nb/ha/index.html

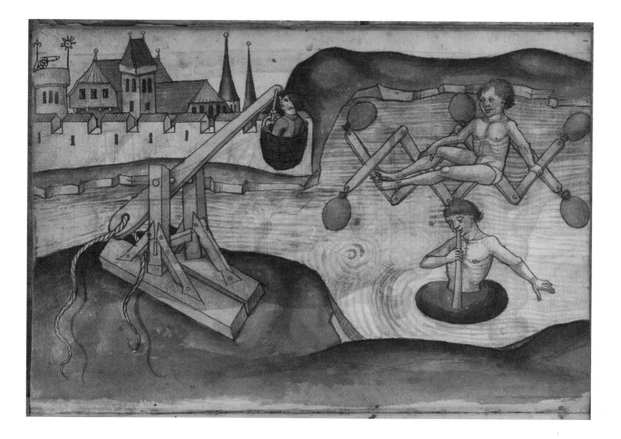

Dergliche wol ist diser fich ist gewun das er oberster nodecket ist
mit aine schwartz helm vnd auch die ougen dar vnd gemachet
als vor. Ist dz das wasser schads runet So seht dich besschwartz
mit schwitzt oder ain pul hinden an aine hou dz an aine
fus das du dar an herus mugst komen

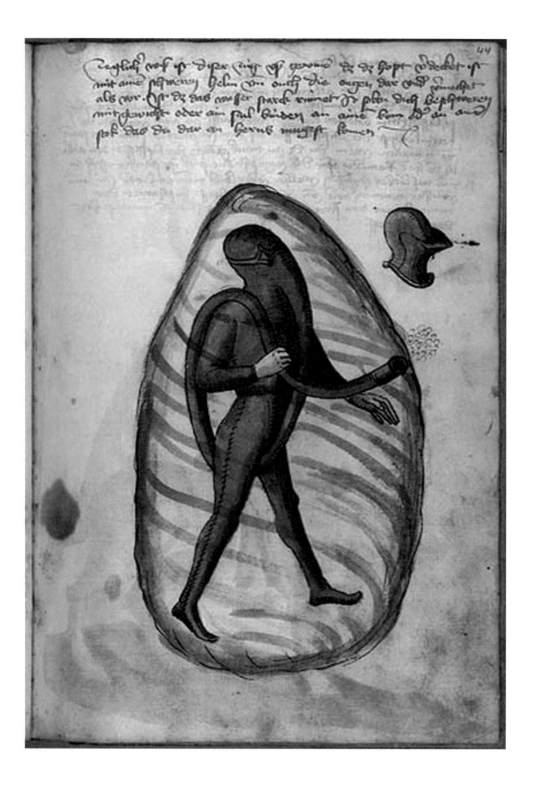

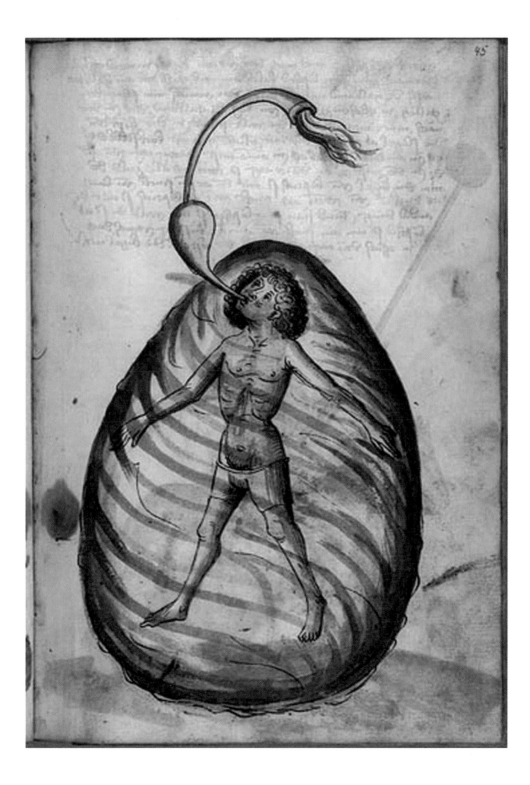

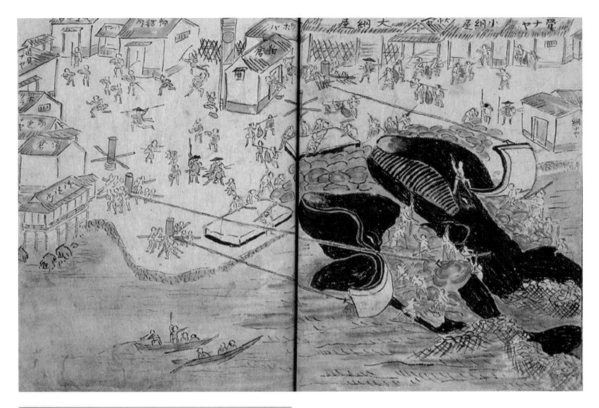

Whaling manuals, 1603-1868

Kyushu University Museum in Japan has an extensive collection of whaling manuals produced during the Edo period (1603-1868). The books range from the purely instructional, with paintings and woodblock illustrations of various species types, tools and methods of slaughter, to folklore tales and recordings of historical events involving whales or the whaling industry. Finding the books requires negotiating the Japanese section of the site.

– – –

KYUSHU UNIVERSITY MUSEUM
http://www.museum.kyushu-u.ac.jp

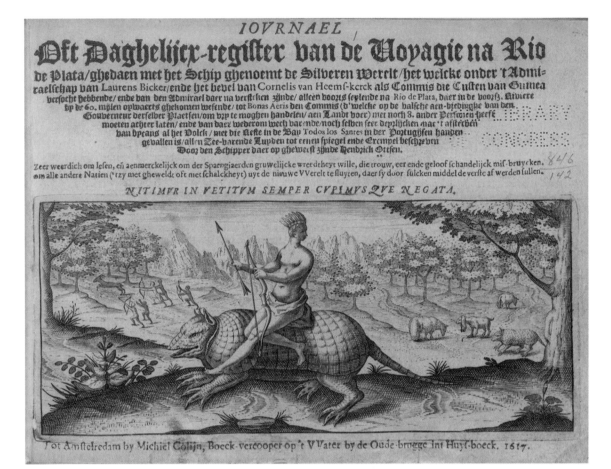

Journal of the Voyage to Rio de Plata
Hendrick Ottsen, 1603

The Dutch voyage in 1598 of two ships to Guinea, Brazil and Argentina was plagued by disaster and it was miraculous that an account of their tales was ever published. The ships were attacked by the Portuguese and became damaged and separated during ferocious storms. The crew were imprisoned for illegal trading and their numbers diminished due to scurvy. After losing a Captain, only one of the ships limped home to Holland in 1601, carrying the ship's master and journal author, Hendrick Ottsen. The final line in the full version of the book's long title remarks that the journal was meant as a warning 'for all seafaring people'. The fantastical representation here of an armadillo and lounging native typifies the early distorted views of the Americas held by Europeans.

— — —

EXPANDING FRONTIERS, COMPARING CULTURES COLLECTION, LIBRARY OF CONGRESS
http://international.loc.gov/intldl/brhtml/brhome.html

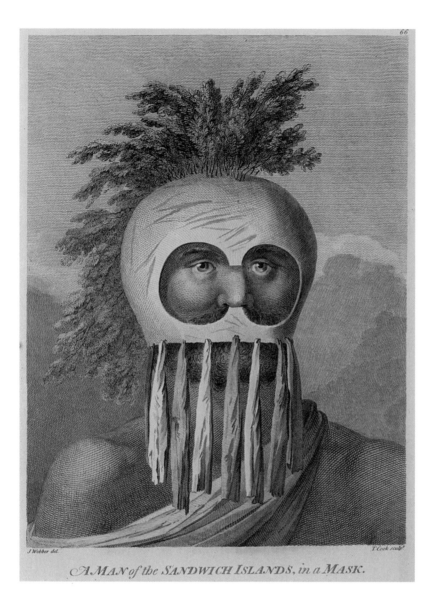

J. Webber del. T. Cook sculp.

A MAN of the SANDWICH ISLANDS, in a MASK.

A Man of the Sandwich Islands, in a Mask
A Young Woman of Otahette, bringing a Present
John Webber, 1784

Swiss born John Webber was the official artist for Captain Cook's third voyage to the Pacific region during the years 1776-1780. He was charged with recording the most memorable scenes of the journey 'as may fall within the compass of his abilities'. The drawings and watercolours he made with a second artist, William Ellis, provided the first accurate ethnographic record of Pacific culture.

The engravings from Webber's original sketches of a woman from Tahiti and a man from Hawaii are from Volume IV of Cook's *Voyage to the Pacific Ocean*, 1784.
– – –
NATIONAL LIBRARY OF AUSTRALIA
http://www.nla.gov.au

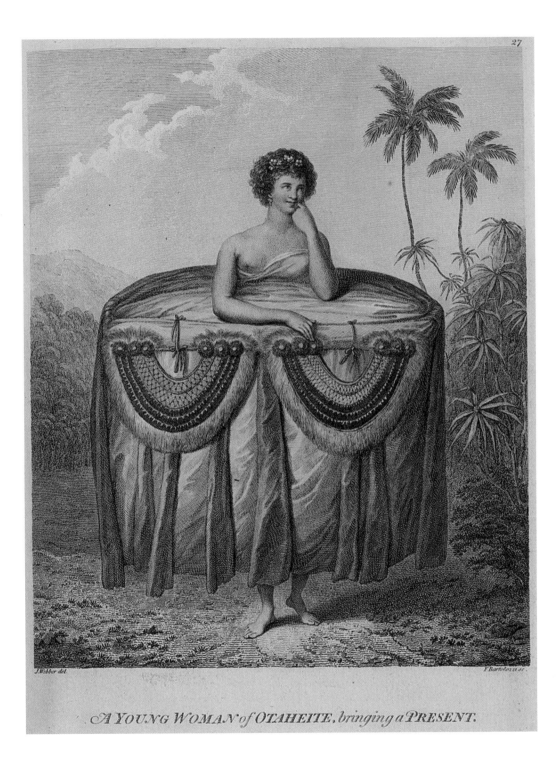

J.Webber del.

F.Bartolozzi sc.

A YOUNG WOMAN of OTAHEITE, bringing a PRESENT.

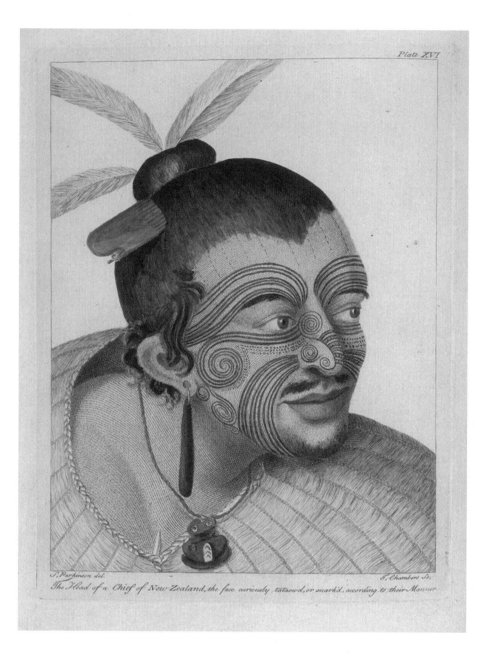

Plate XVI

The Head of a Chief of New Zealand, the face curiously tataowd, or snark'd, according to their Manner.

J. Parkinson del. T. Chambers Sc.

The Head of a Chief of New Zealand, the Face Curiously Tataowd or Snark'd According
Sydney Parkinson, 1773

Quaker roots in Scotland instilled a strong work ethic in Sydney Parkinson who pursued draughtsmanship training on top of his drapery apprenticeship to broaden his skill set. His proficiency with the former led him to London where he was discovered sketching plants at a nursery by the eminent botanist, Joseph Banks. He recruited Parkinson to be chief artist for Captain Cook's first southern voyage in 1768 aboard HMS Endeavour to Brazil, New Zealand and Australia. For about three years, Parkinson diligently and tirelessly sketched the vast array of botanical specimens presented to him (many only published in the 1990s), even going so far as to engage in covert night collection raids for plants when a political impasse kept their ship offshore in Brazil. After illness took the life of the ship's landscape artist, it fell to Parkinson to perform both roles. The next port visit gave him the opportunity to display his portrait sketching abilities on the local Maori population, including this drawing which was published in Parkinson's posthumous 1773 journal. Parkinson had succumbed to one of the infections that ravaged the crew on their homeward voyage.

– – –

DIXSON LIBRARY, STATE LIBRARY OF NEW SOUTH WALES
http://www.sl.nsw.gov.au/online

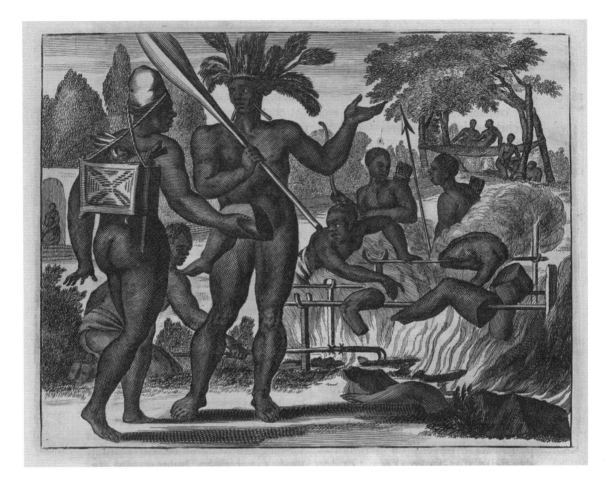

The Toponaques
Arnoldus Montanus, 1671

Arnoldus Montanus collected stories from merchant
mariners in Amsterdam which formed the backbone of an
expansive book on the Americas (mostly) called *De
Nieuwe en Onbekende Weereld* (The New and Unknown
World). His theological publishing and Jesuit background
probably skewed editorial control over the uncredited
illustrations, which tended towards portraying native
populations in a heathen and barbarous light. Many more
fine engravings of flora, fauna and scenic views together
with excellent quality maps ensured it became a standard
reference volume and was popularly received. So popular
in fact that brazen plagiarists in both England (Ogilby) and
Germany (Dapper) released nearly identical books very
soon after with the same illustrations, but without any
credit for Montanus. This was despite his printer, Jacob
van Meurs, having received a contemporary form of
copyright protection by way of privilege granted by the
States of Holland. (see also page 92)

– – –

THE ATLANTIC WORLD: AMERICAN AND THE NETHERLANDS,
NATIONAL LIBRARY OF THE NETHERLANDS
AND THE LIBRARY OF CONGRESS
http://international.loc.gov/intldl/awkbhtml/awkbhome.html

Pearlie
Eliza Brightwen and Theo Carreras, 1895

Inmates of My House and Garden was Eliza Brightwen's
attempt to convey the enjoyment she experienced patiently
observing and interacting with the birds, animals and
insects at her estate in Middlesex. Aimed at inspiring an
interest in natural science among young people,
Brightwen's personal anecdotes and advice usually related
to common species, but her menagerie sometimes
included more exotic specimens. Of Pearlie, a lemur, she
wrote: 'His great delight in cold weather is to be allowed
to sit on a hassock before the drawing room fire and bask
in its warmth. The instant he is seated before the cheerful
blaze, up go his little arms in a worshipping attitude like
a veritable Parsee.' Brightwen collaborated with Theo
Carreras to produce the illustration of Pearlie, part of the
Women in Nature exhibition site.

— — —

SPECIAL COLLECTIONS,
UNIVERSITY OF WISCONSIN-MADISON MEMORIAL LIBRARY
http://www.library.wisc.edu/libraries/SpecialCollections/womennature

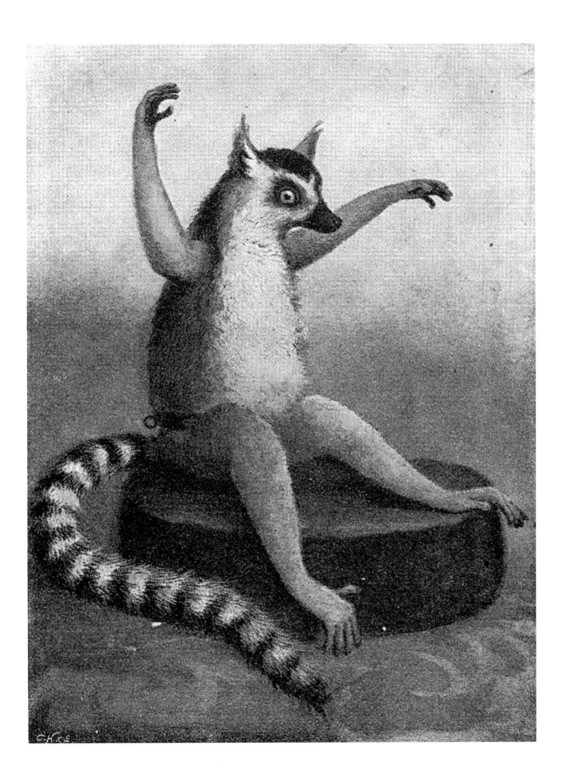

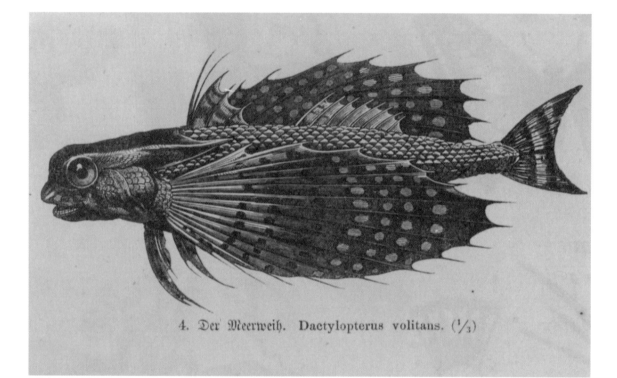

4. Der Meerweih. Dactylopterus volitans. ($^1/_3$)

Dactylopterus volitans
Ernst Fröhlich, 1858

German chemist and teacher, Hugo Reinsch, combined
forces with science illustrator, Ernst Fröhlich, to produce
the 1858 school text, *Naturgeschichte in Bildern*
(Natural Science in Pictures). The ray-finned fish (flying
gurnard) illustration reproduced here is a detail from a
large instructional, multi-figure diagram.

– – –

Voyage a la Lune, 1870

Overleaf:
Vauxhall. Mr. Green (advertisement), c.1830
Henri Lachambre balloon (advertisement), c.1880

Anonymous

The brothers Gaston and Albert Tissandier were both ballooning enthusiasts in the late 19th century, and avid collectors of ephemera relating to the history of aeronautics, particularly in Europe. Their tastes ranged from technical drawings and historical views of flying machines and airships, through portraits and photographs of famous balloonists, to posters and broadsides that made fun of the new fangled machines of flight.

– – –

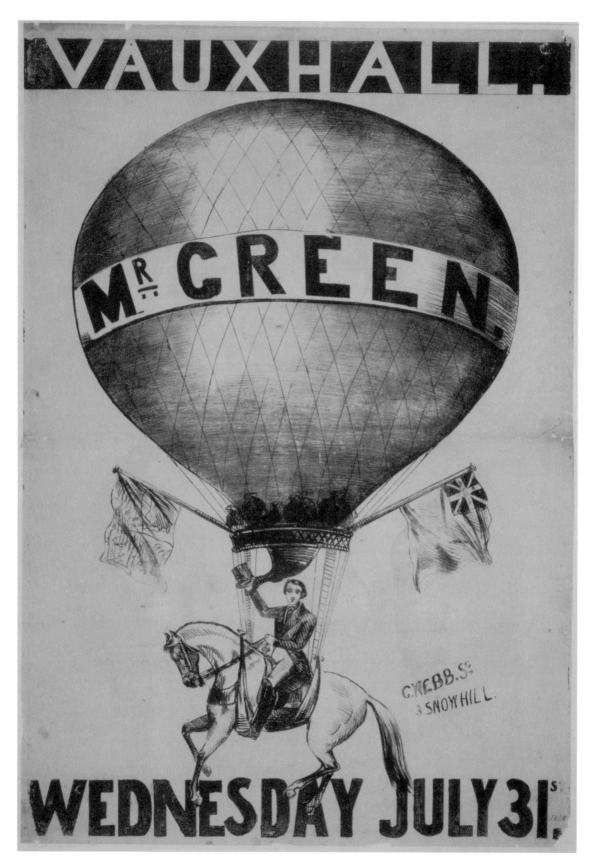

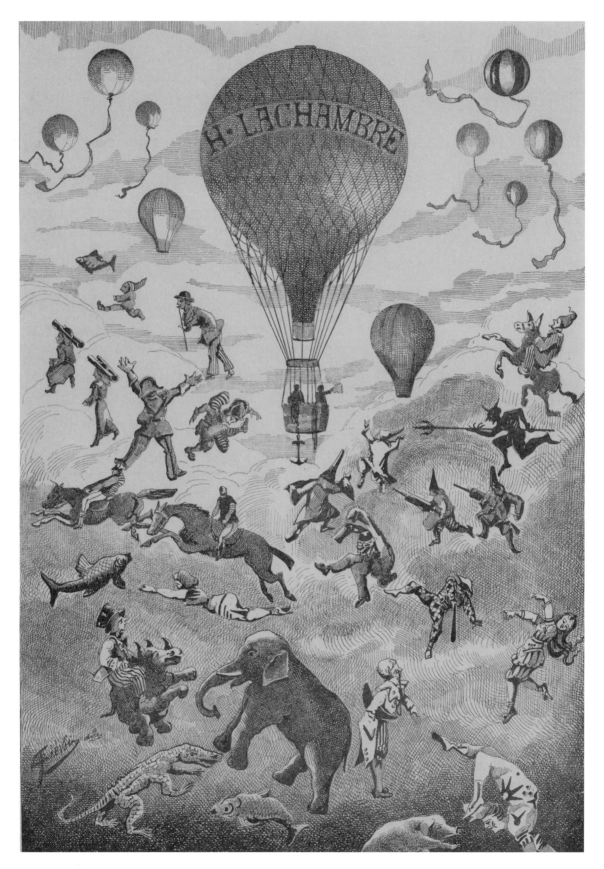

47

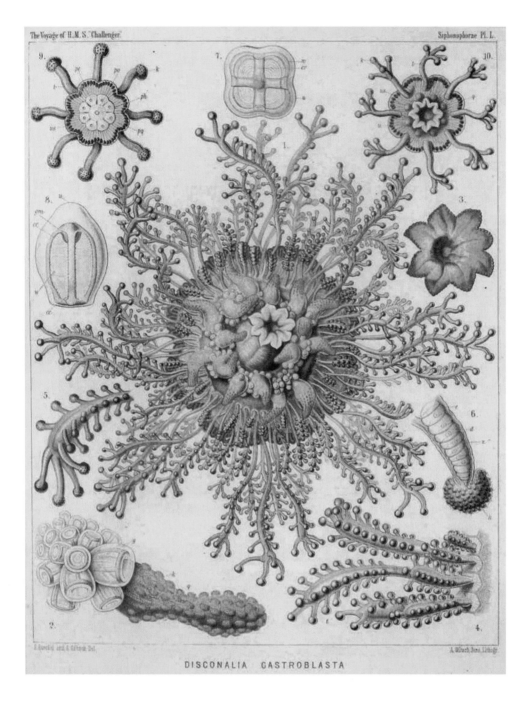

DISCONALIA GASTROBLASTA

Illustrations from HMS Challenger Library, 1873-1876

Between 1873 and 1876, the refitted former naval corvette, HMS Challenger, sailed nearly 70,000 miles around the world in one of the most extensive scientific explorations of all time. A large number of scientists from diverse fields collaborated to map, measure and dredge the ocean depths, while ethnographic and biological data were collected during each port visit. More than 4,000 new species of marine and land animals were identified and the expedition is most notable for establishing oceanography as a scientific discipline. It took twenty years, 30,000 pages and fifty volumes to publish all the results. [Note: the *Disconalia gastroblasta* print is by Ernst Haeckel (see page 22) and would be later adapted for his *Kunstformen der Natur* book]. The zoology and botany reports have been digitised from the library holdings of Dartmouth College in New Hampshire.

– – –

LIBRARY OF 19TH CENTURY SCIENCE
http://www.hmsc.19thcenturyscience.org

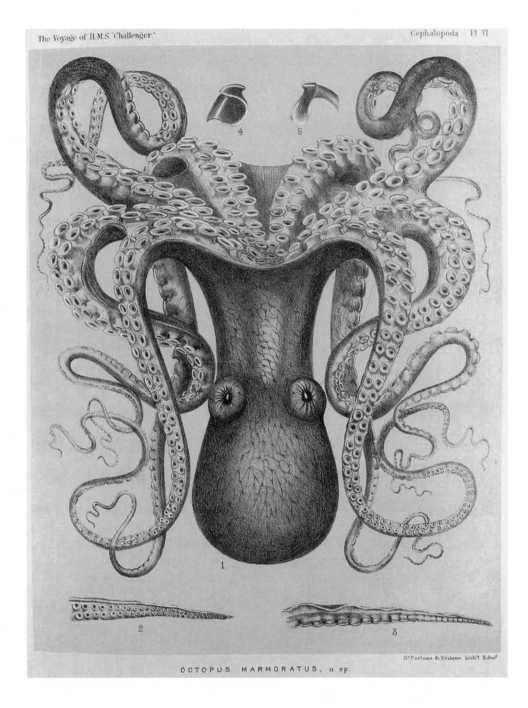

OCTOPUS MARMORATUS, n. sp.

Plate 100. Legion Phaeodaria. Order Phaeogromia.
Family Tuscarorida.

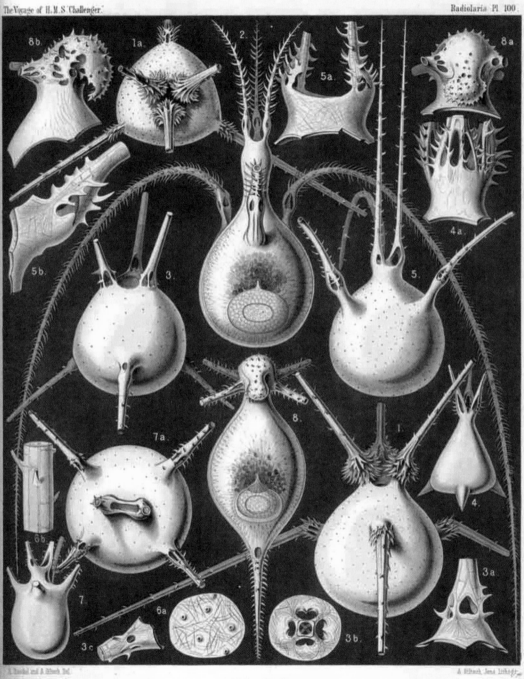

TUSCARORA.

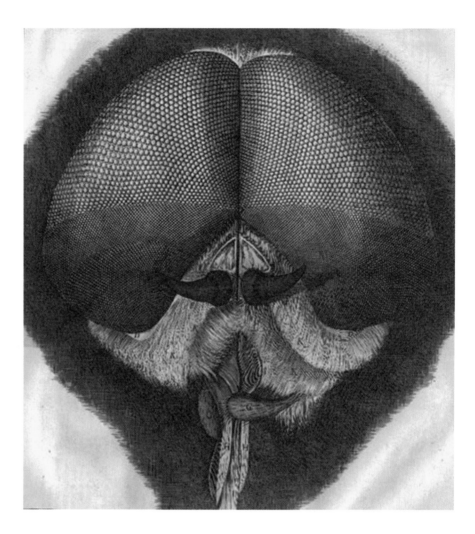

The Eyes of a Fly
Robert Hooke, 1665

The word *polymath* hardly begins to intimate the extent of contributions to science and 17th century intellectual thought made by Robert Hooke. Among his many accomplishments he: assisted Robert Boyle in the formulation of Boyle's Law; helped redesign London following the Great Fire; designed the universal joint for vehicles, the iris diaphragm for cameras and the balance wheel for watches; and was also Curator of Experiments to the newly founded Royal Society. In 1665 Hooke achieved critical acclaim with the publication of *Micrographia* in which, most notably, he recorded his painstaking observations of biological specimens under a compound microscope. The highly detailed engravings of microscopic life from Hooke's own illustrations captured the imagination of a public who had never seen such a miniature world. In his description of cork, Hooke famously introduced the word *cell* to describe the smallest visible structure. Samuel Pepys wrote that *Micrographia* was 'the most ingenious book that I ever read in my life'.

– – –

SPECIALIZED LIBRARIES AND ARCHIVAL COLLECTIONS,
UNIVERSITY OF SOUTHERN CALIFORNIA
http://www.usc.edu/libraries

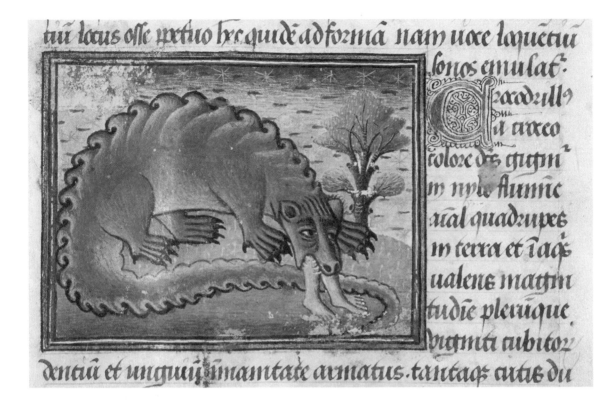

French vellum manuscript illustration
Anonymous, 1450

Bestiaries are part of a tradition that began in the 3rd or
4th centuries AD with the Greek *Physiologus*, a collection
of animal based moral stories widely circulated in Europe.
The allegorical message was enhanced later with
commentary drawn from ancient scientific texts and
contemporary knowledge of the natural world. Mythical
creatures such as dragons and unicorns, that were
commonly believed to exist, were also included. Most
manscripts contained illustrations that served as a visual
language for illiterate people who were familiar with the
stories from hearing sermons. Often, the miniature
paintings of beasts were eccentric and unrealistically
distorted, as the manuscript illustrators may have been
drawing animals they had never seen themselves or were
copying from unreliable sources. This might explain the
outlandish appearance of the *crodrillus* eating a man in
this image from a 1450 French vellum manuscript.
(see also page 139)

– – –
THE NATIONAL LIBRARY OF THE NETHERLANDS AND
MUSEUM MEERMANNO-WESTREENIANUM
http://www.kb.nl/kb/manuscripts

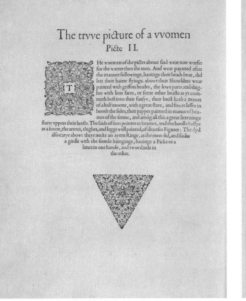

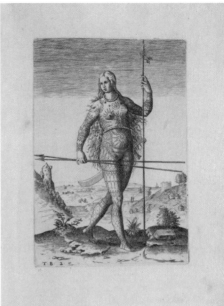

The Truue picture of a women and *The Truue picture of one*
Theodor de Bry, 1590

European perceptions of the New World were significantly
influenced by Thomas Hariot's *A Brief and True Report of
the New Found Land of Virginia*. The exceptional
copperplate engravings from Theodor de Bry were based
on the original watercolour sketches by John White, but
were often embellished with an eye for the European
market. The plates presented the everyday life of the
American natives and the popularity of the work inspired
a subsequent series of illustrated books on Grand Voyages
from the Frankfurt printshop of the de Bry family.

– – –

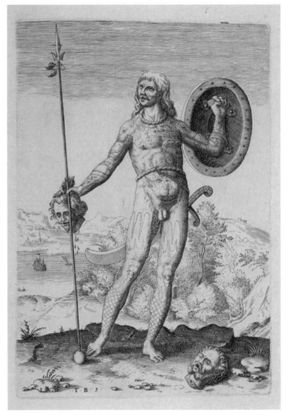

Canis Major and *Perseus* from *Uranographicarum*
Johannes Hevelius, 17th century

NASA's Hubble Space Telescope consortium, The Space Telescope Science Institute in Baltimore, borrowed the 17th century star atlas *Uranographicarum* by Johannes Hevelius from the U.S. Naval Observatory Library. Their intention from digitising the book was to separate out the lush constellation images from the artefact of the medium – creases and age related damage – as well as the impinging nearby stars and reference lines. The ongoing project is using photo manipulation software to build a library of the individual mythological star systems as historic astronomy references and for use in overlay strategies. But the images need to be reversed, because Hevelius mapped the sky as seen from outside the celestial sphere.

– – –

HUBBLE SOURCE, SPACE TELESCOPE SCIENCE INSTITUTE
http://hubblesource.stsci.edu/sources/illustrations/constellations

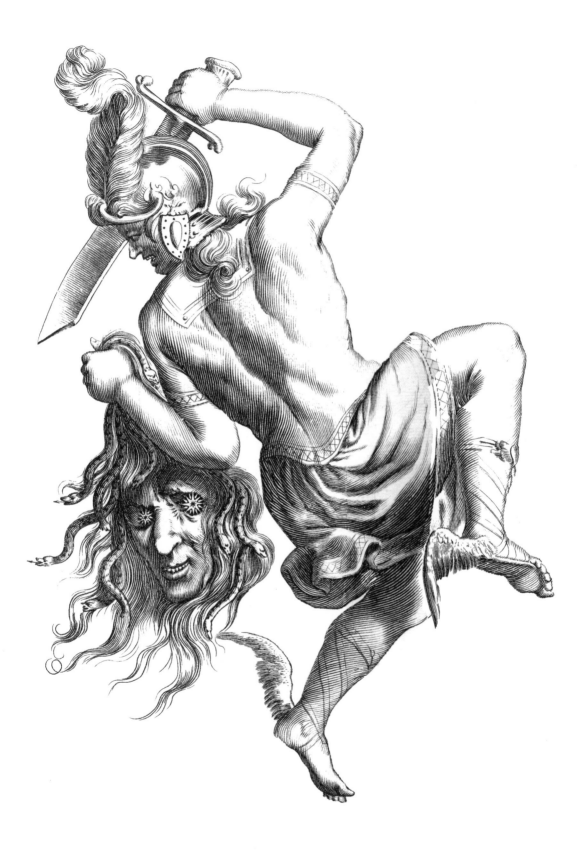

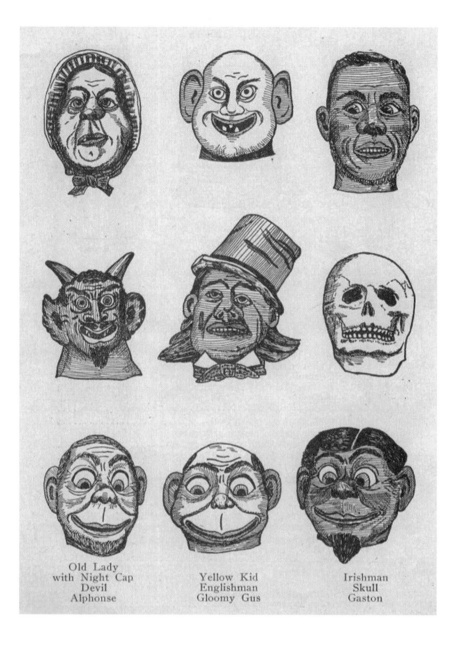

Old Lady
with Night Cap
Devil
Alphonse

Yellow Kid
Englishman
Gloomy Gus

Irishman
Skull
Gaston

Burlesque and Side Degree Specialties,
Paraphernalia and Costumes
De Moulin Brothers Supply Catalog, 1930

Fraternal lodges similar to the Freemasons were extremely popular in America in the early 20th century. They offered both fellowship to enhance social connections and economic insurance for members who might obtain health and death benefits when commercial choices were limited and expensive. To expand its number, the Modern Woodmen of America decided to add humorous pranks to the initiation ceremonies of new recruits. A supply company was formed in Illinois by the De Moulin Brothers, who made all kinds of crazy practical joke devices which they sold to the lodges. Products included bucking goats, electrified carpets, trick chairs, scary masks and paddling machines. All were intended to shock, bruise and frighten new initiates, who recovered from their baptism of horseplay and participated enthusiastically when the next intake of candidates arrived. The idea was a huge success and was soon adopted by most lodges in America.

– – –

PHOENIXMASONRY MASONIC MUSEUM
http://www.phoenixmasonry.org

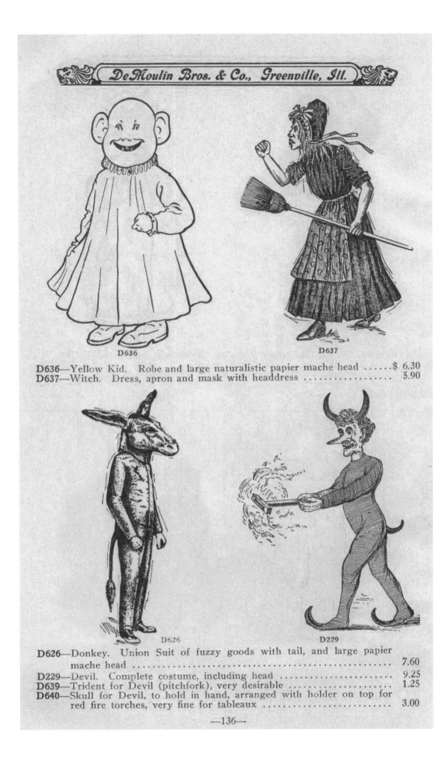

D636

D637

D636—Yellow Kid. Robe and large naturalistic papier mache head$ 6.30
D637—Witch. Dress, apron and mask with headdress 5.90

D626

D229

D626—Donkey. Union Suit of fuzzy goods with tail, and large papier
 mache head ... 7.60
D229—Devil. Complete costume, including head 9.25
D639—Trident for Devil (pitchfork), very desirable 1.25
D640—Skull for Devil, to hold in hand, arranged with holder on top for
 red fire torches, very fine for tableaux 3.00

—136—

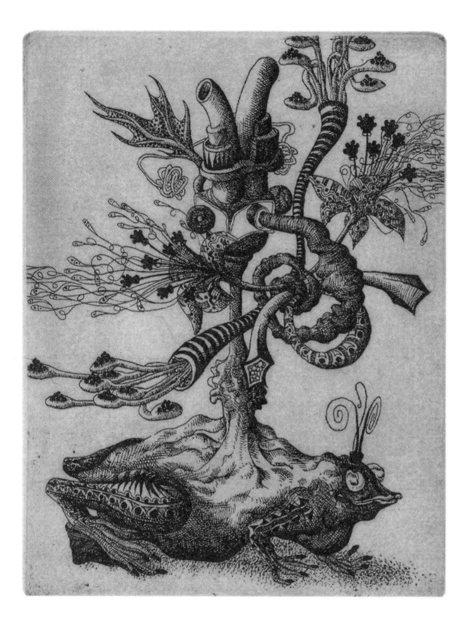

Frog
François Houtin, 1974

In one of his earliest forays into printmaking, landscape gardener turned etcher, François Houtin, conspicuously displays a penchant for what might be termed, 'natural fantasy'. As his style developed, the surreal elements became gradually subdued and the focus shifted more towards recognisable, but never quite realistic, tree and plant forms in imaginary gardens. Houtin's work is often inspired by the formal garden arrangements of early modern Europe. The horticultural visions, incorporating manicured topiaries, illusory dreamscapes, botanical architecture and ornamental designs that Houtin could not produce in his landscaping work are given life through his large portfolio of prints.

– – –

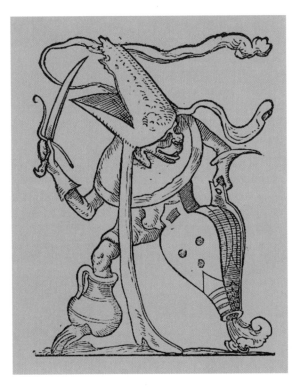

Les Songes Drolatiques de Pantagruel
François Desprez, 1565

Les Songes Drolatiques de Pantagruel (The Amusing
Dreams of Pantagruel) was printed by Richard Breton in
1565, and it was claimed that the one hundred and twenty
absurdist woodcuts (accompanied only by an introduction)
were designed by François Rabelais. The Renaissance
monk and physician had died a decade earlier leaving
behind one of the great classics of literature, a bawdy
carnivalesque epic about the adventures of a giant and his
son, *Gargantua and Pantagruel*. The fantastical
illustrations are drolleries in the manner of Bosch and
Bruegel and are humorous in their own right, irrespective
of whether one believes that they are grotesque caricatures
of prominent citizens of the period or are representations of
characters or scenes from the *Gargantua and Pantagruel*
text itself. Although the first edition is very rare, the
collection has been reproduced periodically since 1565,
and proved to be influential with artists such as Callot,
Goya, Doré and Dalì. Detailed analysis in the early 20th
century concluded that the original drawings were almost
certainly produced by the french artist François Desprez
and not Rabelais. Desprez had worked with Breton earlier,
creating a series of odd fashion plates with comparable
artistic style to *Les Songes Drolatiques*.

– – –

Speculum Humanæ Salvationis
Anonymous, 1420

The anonymous *Speculum Humanæ Salvationis* (The Mirror of Human Salvation) was written around 1300 and is one of the most important and influential books in the history of printing. It is an interpretative biblical commentary, showing how the stories from the Old Testament prefigured the events in the New Testament. It also attempted to indoctrinate people with ideas about the need for salvation and the dread of eternal damnation. The book contained a core sequence of imagery that was copied widely, forming an historically significant compilation of regional illustration styles and interpretations. It is the only work known to exist in manuscript, block book *and* incunabula forms. The source of the work shown is a German parchment manuscript from 1420.

– – –

DEPARTMENT OF MANUSCRIPTS & RARE BOOKS
ROYAL AND NATIONAL LIBRARY OF DENMARK
http://www.kb.dk/en/kb/nb/ha/index.html

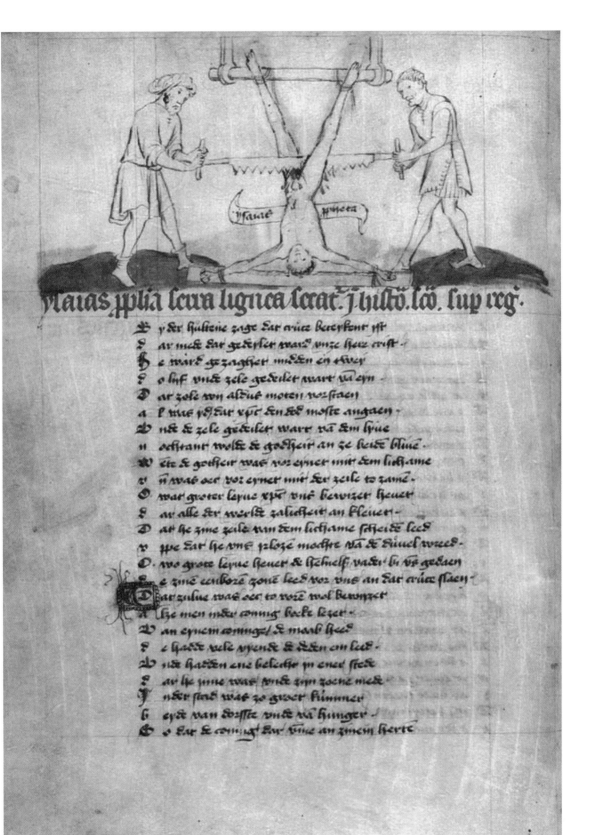

ylaias ꝑplia leura lignea lerat. j hulto. leo. lup reg.

By der hulteue zage dar cruce bekerkent ist
Dar mede dat gedeilet ward unze herr crist
He ward gezaghet mitten en twey
So lyf unde zele gedeilet ward ra eyn
Dar zele von aldus moten vorstaen
Al die vor dat eyt den god moste angaen
Unde de zele gedeilet ward ra em hue
Oehstant wolde de godheit an ze leide blive
Wete de godheit was vor eynet mit dem lichame
Un was oer vor eynet mit der zele to zame
Do war groter leyne xpus unde bewiret heuer
Dar alle der werlt zalicheit an kleuer
Dat he zine zele van dem lichame scheidē leed
Uppe dat he uns ꝑloze mochte ra de diuel wreed
Do wo grote leyne heuer de schulds vader bi uns gedaen
He zine eynboren zone leed vor uns an dat cruce slaen
Dat zulue was oer to vore wol bewyret
Alze men inde coning boeke lezet
Van eynem coninger/ de marb steed
He hadde vele vyende de deken en leet
Unde hadden ene belecht yn ener stede
Dar he zine was unde zyn zoene mede
Inder stede was zo grort kummer
Eynt van dorste unde ra hunger
So dat de coninck dar hue an zinem herte

61

Sæmundar og Snorra Edda
Ólafur Brynjúlfsson, 1760

The legends of Norse mythology are chronicled in two Icelandic works produced between the 10th and 13th centuries. The *Poetic Edda* and *Younger Edda* are themselves compilations of alliterative poetry, folklore narratives and a textual comprehension guide, gathered together from the oral tradition. They served as the source material for Ólafur Brynjúlfsson's manuscript, *Sæmundar og Snorra Edda*, which includes a number of striking illustrations to accompany the dramatic and apocalyptic nature of the myths.

– – –

DEPARTMENT FOR MANUSCRIPTS & RARE BOOKS,
ROYAL AND NATIONAL LIBRARY OF DENMARK
http://www.kb.dk/en/kb/nb/ha/index.html

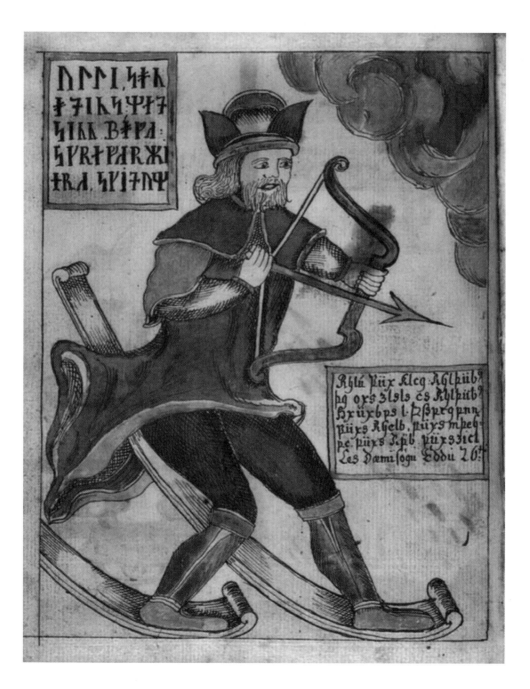

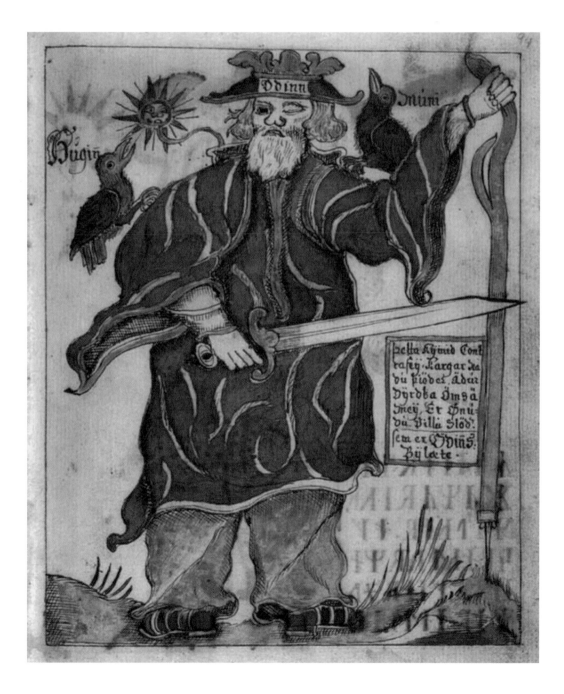

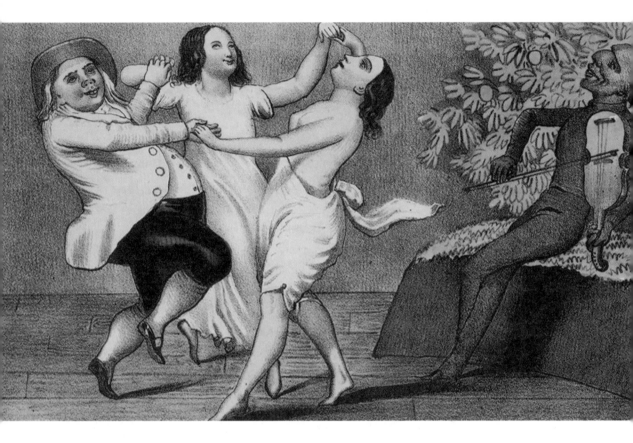

A Mormon and His Wives Dancing to the Devil's Tune
Increase and Maria Van Deusen, 1850

It is safe to assume that Increase and Maria Van Deusen were not enamoured with the Mormon church, which they joined in Illinois in the 1840s. By the end of that decade, they had published a succession of denunciations of the church and it's temple initiation ceremony. The illustration here comes from a book, somewhat ambiguously titled: *Startling Disclosures of the Wonderful Ceremonies of the Mormon Spiritual Wife System*. Being the celebrated 'endowment', as it was acted by upwards of twelve thousand men and women in secret in the Nauvoo Temple in 1846, and said to have been revealed from God.

– – –

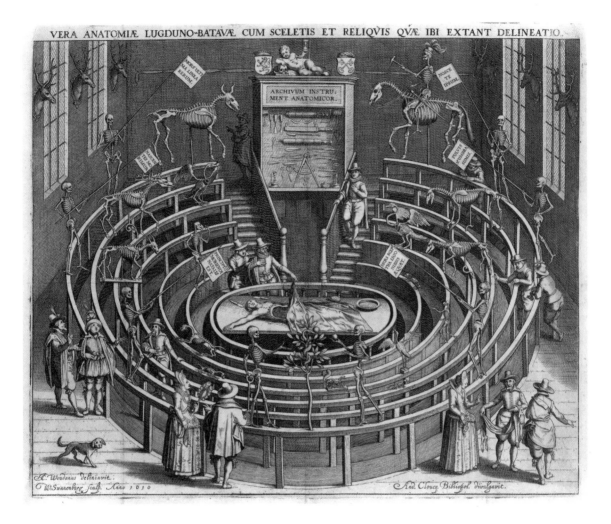

VERA ANATOMIÆ LUGDUNO-BATAVÆ CUM SCELETIS ET RELIQVIS QVÆ IBI EXTANT DELINEATIO.

Theatrum Anatomicum
Willem Swanenburg, 1610

This extraordinary engraving of Leiden Anatomical Theatre by Willem Swanenburg, after a drawing by Jan Woudanus, was originally offered for sale to visitors to Leiden University as a souvenir. It presents an array of potent symbols. The trophies hung on the wall and assortment of animal skeletons suggest origins in the *Wunderkammer* (cabinet of curiosities) tradition: the popular collection mentality of the 17th century. It operates as a *momento mori* (reminder of death) with Adam and Eve standing in the foreground alongside an apple tree, ringed by skeletons carrying warning signs that read – 'to be born is to die' and 'Death is the line that marks the end of all'. It serves as a visual record of the early 1600s and also as a contemporary advertisement in its depiction of well to do types strolling through the amphitheatre.

– – –

LEIDEN UNIVERSITY LIBRARY AND EVERYTHING VIRTUAL
http://www.everything-virtual.org

Real Pen Work, 1881

'*Real Pen Work Self-Instructor in Penmanship*. Published by Knowles & Maxim, Pittsfield, Massachusetts. Price One Dollar. Greatest means ever known for learning to write an elegant hand. Nothing like it ever published before. Something entirely new. Something that everybody wants. Something that has the most enthralling interest for all. The Real Pen Work Self-Instructor in Penmanship contains more copies, more ornamental work, and more and better instructions, for learning the whole art of penmanship without a teacher, than any other work ever published in the world. Everything is explained in such a plain and simple way, that anyone, no matter how difficult writing may naturally be to him, can learn to write a in beautiful hand in an incredibly short time. No other publishers in the world are giving the people as much for the money. Nothing like it ever known before. The largest and most elegantly illustrated work on the subject of penmanship ever published in the world. Expert penmen and men of learning everywhere all admit that the Real Pen-Work Self-Instructor is the greatest means ever known for learning to write an elegant hand. Copyright 1881, by Knowles & Maxim, Publishers.'

– – –

IAMPETH RARE BOOKS (The International Association of Master Penmen, Engrossers and Teachers of Handwriting) http://www.iampeth.com

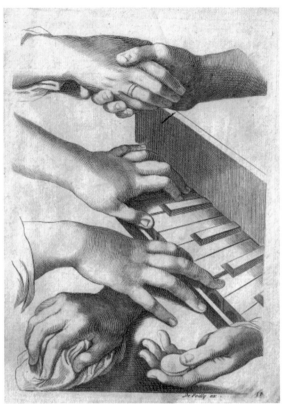

Livre de portraiture d'Annibal Carrache
François de Poilly, 17th century

Annibale Carracci belonged to a family of artists from
Bologna and was a significant driving force for the
development of the baroque style, bringing back classical
and Renaissance elements in a move away from
mannerism. His great legacy remains the rich, illusionistic
ceiling frescoes in the Palazzo Farnese in Rome, depicting
human love governed by celestial love. He made
hundreds of sketches for the frescoes, an approach that
became the standard preparation for any ambitious work
of art. It was Carracci's interest in achieving a
composition as close to nature, and therefore as
believeable as possible, that compelled him to produce
numerous drawings, varying the light or viewing angle
of his subjects. It was not always a formal technique
however. Carracci is also widely credited with developing
the caricature as an independent art form. A series of his
studies were published as engravings by François de
Poilly in a 17th century drawing manual and are probably
derived from the Palazzo Farnese ceiling sketches.
– – –

THE ELECTRONIC LIBRARY OF LISIEUX
http://www.bmlisieux.com/galeries/index.html

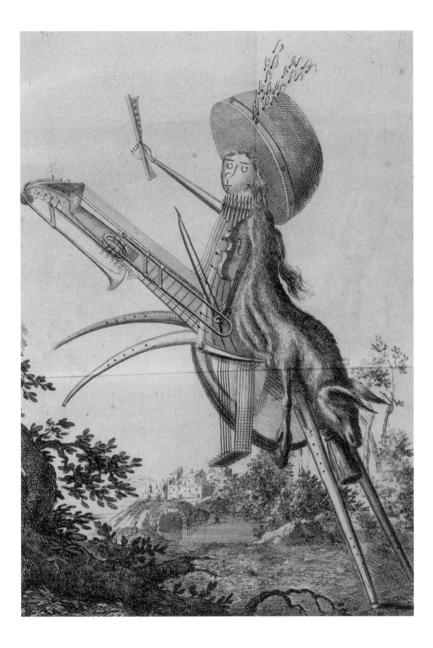

Drawing of Musical Instruments as Animal
From *Bellum Musicum*
Johann Beer, 1701

Johann Beer was an Austrian baroque composer, music
critic, novelist (who published under pseudonyms) and
occasional illustrator. His posthumous *Bellum Musicum*
(Musical War) combined his literary and musical passions
for a story in which the heroines, *composition* and *harmony*,
engage in a pitched and bloody battle, but are eventually
reconciled. The book included an imaginary map of the world
of music together, with the featured anthropomorphic being.

– – –

BEINECKE RARE BOOK AND MANUSCRIPT LIBRARY,
YALE UNIVERSITY
http://www.library.yale.edu/beinecke/index.html

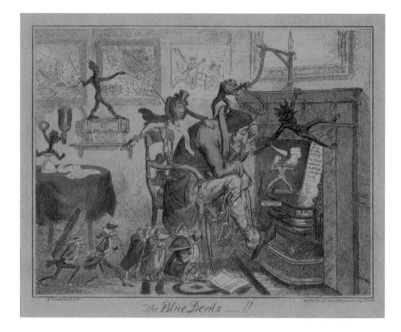

The Blue Devils
George Cruikshank, 1835

Like Gilray before him, George Cruikshank was raised in the Hogarth tradition of pictorial satire: a rollicking indelicate vitality, emblematic of the early British illustrators. Cruikshank came from a family of humorous artists. Although he cut his teeth early engraving political and social caricatures, he also produced a large number of book illustrations, most notably for Dickens.

His sharpness was perhaps later subdued as he developed a close relationship with the temperance movement. This distaste for alcohol, resulting from his own father's death from the bottle, can be seen in one of the many symbolic motifs Cruikshank associates here with depression or *The Blue Devils*. The origin of the expression (which later inspired the musical genre title, *the blues*) is somewhat obscure. *Blue* probably derives from the hellish flames of brimstone; with literary instances going back to the 17th century, and perhaps even as far back as Chaucer. Cruikshank's wonderfully morbid study has the forlorn debtor offered noose and scalpel to escape life's miseries while another little devil sketches a disaster into a scene from his life hanging on the wall.

(see also page 10)

– – –

HARVARD MEDICAL LIBRARY,
FRANCIS A. COUNTWAY LIBRARY OF MEDICINE
http://www.countway.harvard.edu/rarebooks

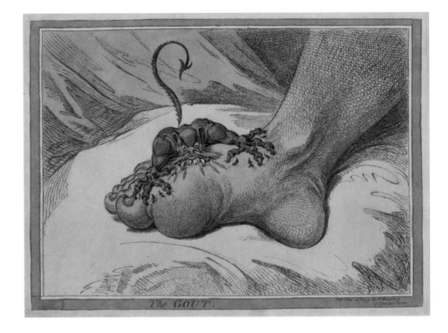

The Gout
James Gilray, 1799

No serious assessment of life in late 18th century Britain –
whether in social, political or artistic terms – would be
complete without including a reference to one or more of
the incisive prints made by James Gilray. The coarse
humour and biting satire he brought to his coloured
etchings established Gilray as the first truly professional
caricaturist, and ushered in a golden age for British
illustration. He documented the mood of the public, the
historical events and fashions of the day *and* lampooned
the high and mighty, both at home and abroad (Napoleon
was a favourite target). Later in life, as a consequence of
his drinking, Gilray suffered from intermittent episodes of
gout, described by some people as the most acutely
exquisite of all pains. Fellow sufferers can no doubt
identify all too readily with the potent imagery he employs
to capture this agony.

– – –

HARVARD MEDICAL LIBRARY,
FRANCIS A. COUNTWAY LIBRARY OF MEDICINE
http://www.countway.harvard.edu/rarebooks

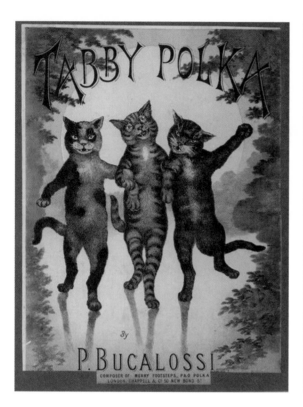

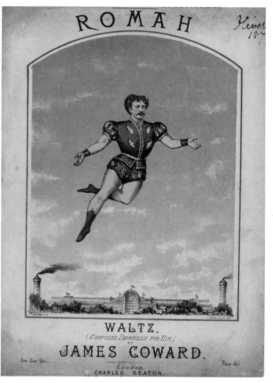

Tabby Polka
Anonymous, c.1880
Romah
Watson, c.1870-1880

Taken In and Done For
Concanen & Lee, 1865

Music sheet covers were big business in the 19th century. Changes in technology and social habits fuelled demand for illustrated sheet music, particularly among the Victorian middle-class. Innovations in piano design meant that by the middle of the century, upright pianos became a focus for family entertainment in many homes, in a similar manner to the television set in the 20th century. At the same time, people were attending more choral society performances and public concerts, and informal pub sing-songs were giving way to dedicated singing saloons. There was a growth in purpose built venues – music halls – that greatly contributed to the appeal of certain songs and artists. People clamoured for the music sheets so they could hear the popular music of the day in their own homes. The development of the lithographic printing technique, in which images were drawn with greasy crayons onto limestone, made reproducing vivid colour illustrations easier and cheaper. Subject matter for the covers ranged from the nationalistic and political to the absurd and humorous. Satires and comical images were especially prevalent as a reflection of the often light hearted nature of music hall songs.

– – –

SPELLMAN COLLECTION, READING UNIVERSITY LIBRARY
http://www.reading.ac.uk/library/colls/special/spellman.html

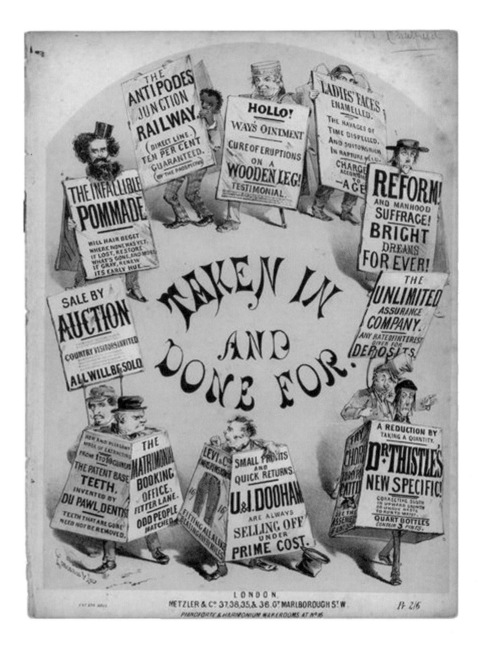

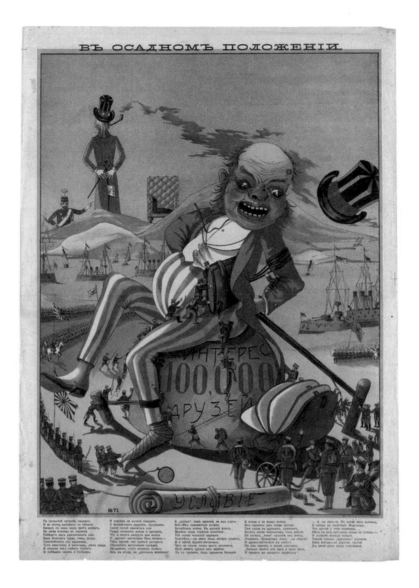

In The State of Siege
1904

We will sit by the sea, we will wait for the weather!
1904
The Japanese Emperor and his cunning well-wishers
1904

Anonymous

The artistic tradition of Russian folk prints was periodically co-opted during times of war as both a vehicle of propaganda and a means for circulating news about battles, particularly among the illiterate peasants. The Russo-Japanese war of 1904-1905 took place in eastern China and the unexpected victory by Japan was one of a number of events that led to the Russian revolution of 1905. The lithographs produced during the war with Japan were typically allegorical, realistic or, in some cases, satirical. As the war progressed, the illustration tone changed from national glorification and mocking racism to serious reporting, as battlefield and naval failures became evident. Finally, poster production ceased altogether, as the handful of central printshops had their work censored when total defeat became inevitable.

— — —

NATIONAL LIBRARY OF RUSSIA AND LIBRARY OF CONGRESS,
MEETING OF FRONTIERS:
TSARIST AND SOVIET POSTERS COLLECTION
http://frontiers.loc.gov

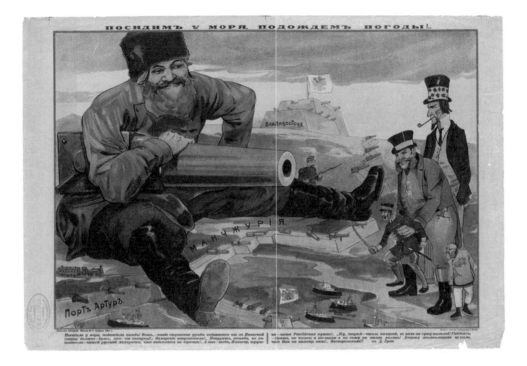

ПОСИДИМЪ У МОРЯ, ПОДОЖДЕМЪ ПОГОДЫ!..

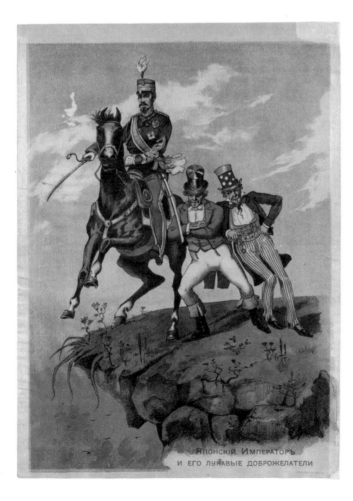

ЯПОНСКІЙ ИМПЕРАТОРЪ
И ЕГО ЛУКАВЫЕ ДОБРОЖЕЛАТЕЛИ

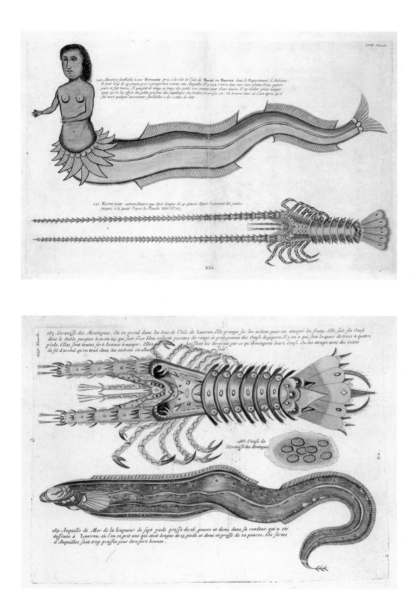

Fishes, Crayfishes, and Crabs, of Diverse Colours and Extraordinary Form
Samuel Fallours, 1719

Exiled Huguenot bookseller and British spy, Louis Renard, gathered together the drawings made for the Dutch East India Company by Samuel Fallours to produce one of the rarest and most fantastic natural history books ever published. The outlandish hand coloured 18th century engravings bring to surreal life more than four hundred species of exotic marine creatures from the Moluccas and Indonesian archipelago. Oddly enough, the only text in the book is engraved onto the illustration plates, advising as to the specimen's characteristics as a menu item, with an occasional brief recipe. There was no reference material for the artists in Holland who embellished the sketches, and in the original preface Renard included (alleged) authenticating testimony, fearing that the vividly coloured images would be challenged. Although obviously fanciful at times, modern scientists consider that the vast majority of illustrations can be associated with known marine species.

– – –

STATE LIBRARY OF NEW SOUTH WALES ONLINE COLLECTIONS
http://www.sl.nsw.gov.au/online

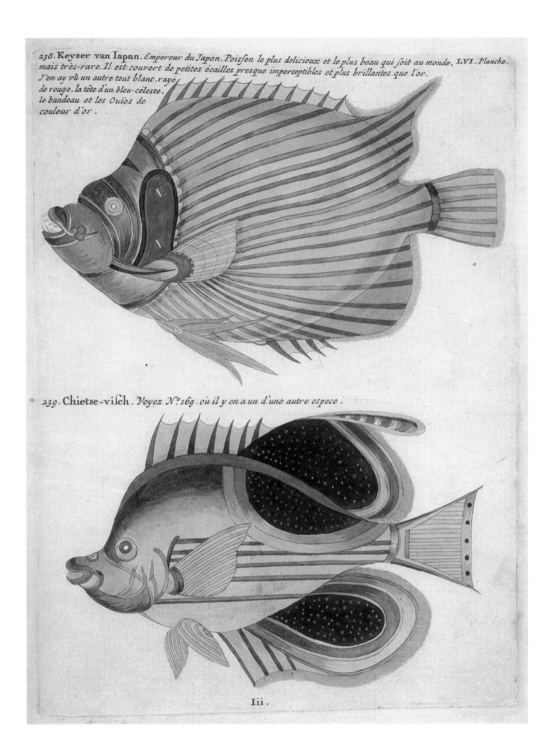

238. Keyser van Iapan. *Empereur du Japon. Poisson le plus delicieux et le plus beau qui soit au monde,* **LVI***. Planche.* *mais très-rare. Il est couvert de petites écailles presque imperceptibles et plus brillantes que l'or.* *J'en ay vû un autre tout blanc, rayé* *de rouge, la tête d'un bleu-céleste,* *le bandeau et les Ouïes de* *couleur d'or.*

239. Chietse-visch. *Voyez N.º 169. où il y en a un d'une autre espece.*

Iii.

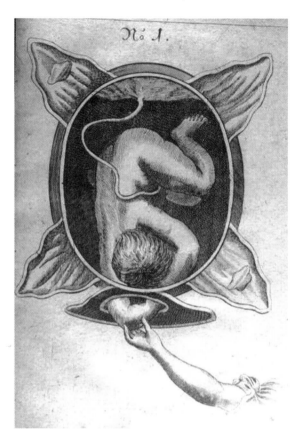

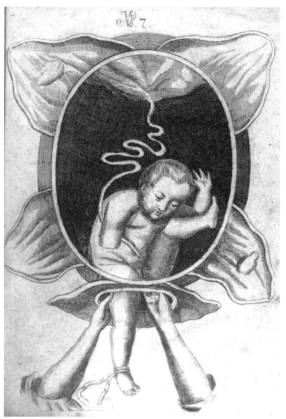

Die Konigl
Justine Siegemund, 1690

With the expansion of scientific and medical enquiry during the renaissance and early modern periods, it was inevitable that the mystical and secretive world of midwifery would become the subject of serious academic interest. It is probably no coincidence that the midwifery profession began to be regulated with the swearing of oaths and licensing during the same time frame. The first recognised text for midwives was published by a male physician, Eucharius Rösslin, in 1516 (*Der Rosengarten*). Although it was rudimentary, it was widely translated and circulated throughout Europe. One of the earliest midwifery texts written by an *actual* midwife was Justine Siegemund's 1690 book, *Hof-Wehe-Mutter* (Court Midwife). Siegemund had endured poor midwifery care when she was wrongly judged pregnant at age twenty and

this fuelled her desire to become trained in the profession. She overcame childlessness (usually a bar to becoming a midwife) and accusations of misconduct by at least two jealous male colleagues, to gain the respect of the Elector of Brandenburg, who appointed her Court Midwife. Her systematic midwifery treatise was based on the practical experience gained from a long career and provided sound advice, not only about embryology and normal childbirth, but also in relation to complications that might be expected.

— — —

THE CLENDENING HISTORY OF MEDICINE LIBRARY,
UNIVERSITY OF KANSAS MEDICAL CENTER
http://clendening.kumc.edu/dc/rti

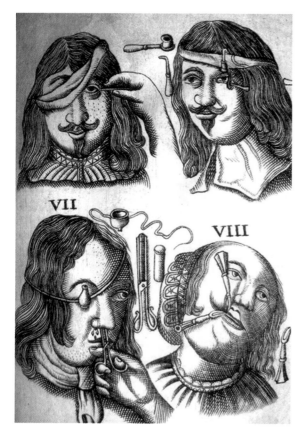

VII

VIII

Armamentarium Chirurgicum
Johannes Scultetus, 1655

Johannes Scultetus was among the first academically trained doctors in Germany in the 17th century. He became the Chief Medical Officer for the city of Ulm during the Thirty Years War and developed lifesaving surgical techniques for head trauma on the battlefield. His magnum opus, *Armamentarium Chirurgicum* (The Surgical Arsenal), was a landmark treatise in the age of rationalism, but wasn't released until ten years after his death. The 1655 book was a complete catalogue of surgical instruments in existence at the time, with numerous copperplate engravings demonstrating selected operative techniques such as the confronting images shown here. Scultetus also provided incredibly detailed case reports about the nature of surgical treatment and the subsequent progress of a hundred of his patients. The book was translated into many languages and became standard reference for a century. It was particularly responsible for improving the quality of education for the untrained barbers of the period, who were performing the majority of surgical procedures.

– – –

COURTESY ALBERTO LUANDI
http://www.ebay.com

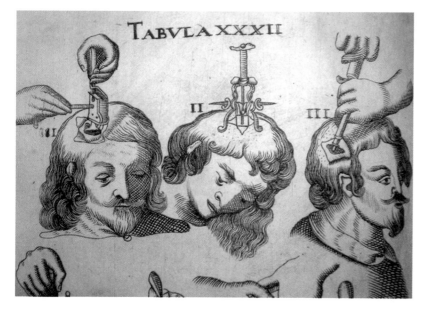

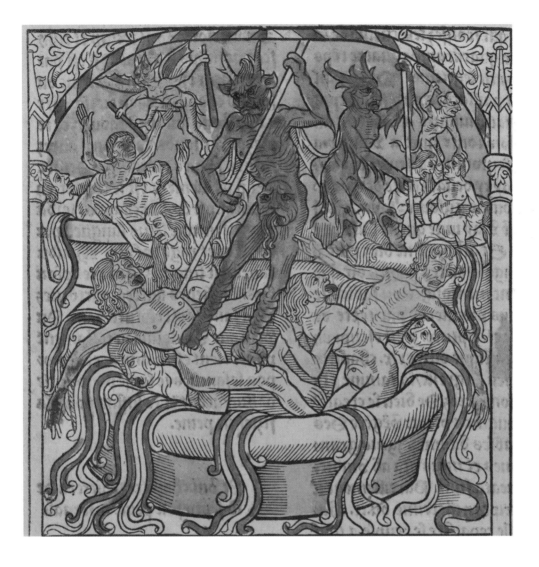

L'Art de Bien Viure et de Bien Mourir, 1453
(Rosenwald 424)

The devastating effects of the black plague in the Middle Ages meant that an early death was a distinct possibility for a person of any status. In an artistic sense, this gave rise to the allegorical and sometimes humorous *danse macabre* (dance of death) illustration series, in which the grim reaper was variously depicted claiming their next victim from all walks of life. It was meant to be a reminder that death was always just around the corner and that one should be prepared. A more practical and religious response to the plague came in the form of two related 15th century manuscripts that served to advise people how they could achieve a good death. Known as *Ars moriendi* (the Art of Dying), the first manuscript outlines the rites and prayers that were recommended at the time of death. The second illustrated manuscript describes a dying person's struggles with temptations and the dire consequences that follow if they lack faith, remain impatient or full of pride and avarice. The graphic woodcut illustrations brought hell, demons and angels into sharp focus, even for those people who couldn't read the accompanying warnings. Salvation (seen in the form of a baby 'being born' from a dying person's head) was only possible by overcoming temptation.
(see also pages 112, 155)

– – –

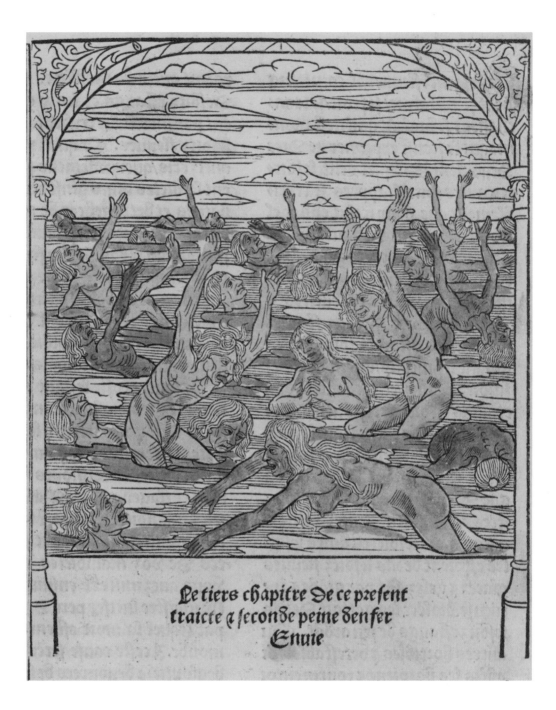

Le tiers chapitre de ce present
traicte a seconde peine denfer
Enuie

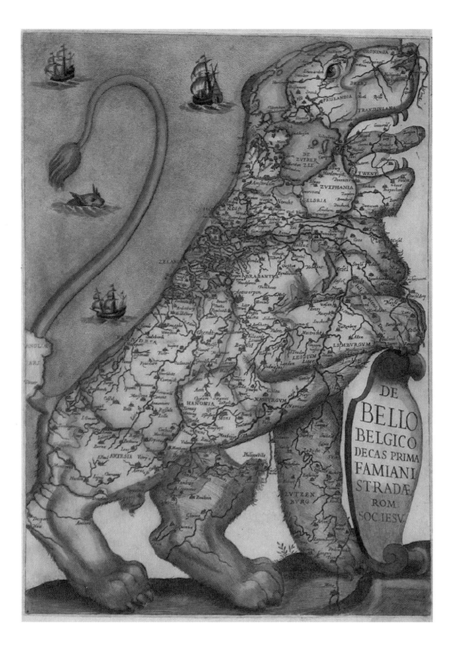

De Bello Belgico
Famiani Strada, 1632

The inventive presentation of the seventeen provinces of the Low Countries in the shape of a lion is referred to as a *Leo Belgicus* map and was first printed in 1583. Austrian Baron Michael Eitzinger included it in his book, *History of the Low Countries*, and he was probably inspired by many of the provinces having a lion in their coat of arms. It proved to be a very popular design and was copied and adapted to the changes in political status over the next two centuries.

– – –

THE MAP HOUSE OF LONDON
http://www.themaphouse.com

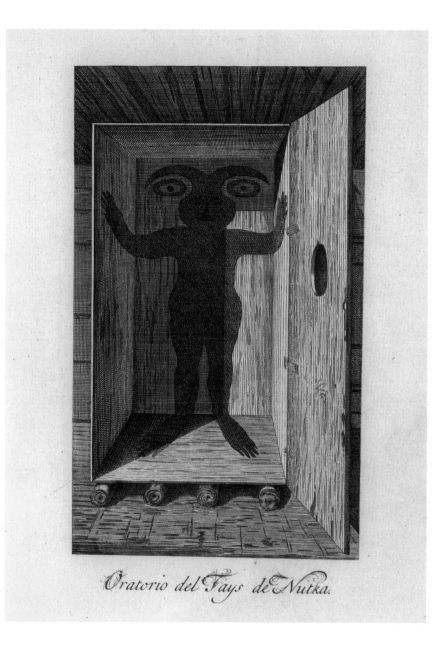

Oratorio del Fays de Nutka.

Oratorio del Fays de Nutka
José Espinosa y Tello, 1802

When Captain Cook first encountered the indigenous peoples of Vancouver Island, he misunderstood when they tried to direct him to a safe harbour and so named them Nutka (go around). These self-named Nuu-chah-nulth native tribes would be nearly wiped out in the following decades by introduced diseases. Spain had a maritime trade monopoly in the Pacific northwest during this period, but a dispute soon developed with Britain and the first of a number of treaties was negotiated in 1790, under the local hospitality of Chief Macuina. The last Spanish expeditionary voyage along the Pacific coast was undertaken in 1792 and the resulting maps, although not published for four years, were considered superior by some to those undertaken by George Vancouver at the same time. *Atlas para el Viage de las Goletas Sutil y Mexicana* by José Espinosa y Tello, included nine maps and eight plates of native portraits together with what is described as the *Praying Room of Macuina*, above.

– – –

DAVID RUMSEY MAP COLLECTION
http://www.davidrumsey.com

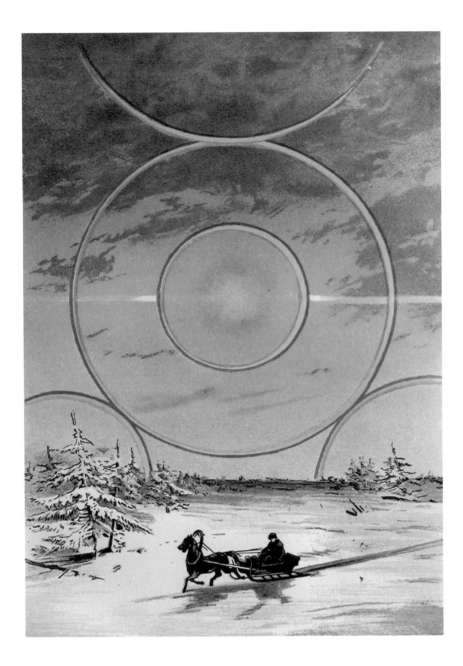

L'Atmosphere: Météorologie Populaire
Camille Flammarion, 1888

Camille Flammarion did much to popularise astronomy in the late 19th century in France. He had worked at the Paris Observatory before establishing his own private observatory just outside the city, and was the founder and first president of the the French Astronomical Society. He remains something of an enigmatic character nonetheless, having divided his publishing output between science fiction and more traditional scientific writing. His passionate belief in both alien life forms and reincarnation featured prominently in his books. An interest in meteorology led Flammarion to take many hot-air balloon flights and he published the acclaimed *L'Atmosphere: Météorologie Populaire* in 1888 from which these two pictures of extraordinary atmospheric phenomena were selected.

– – –

DEPARTMENT OF THE HISTORY OF SCIENCE,
UNIVERSITY OF OKLAHOMA
http://www.ou.edu/cas/hsci

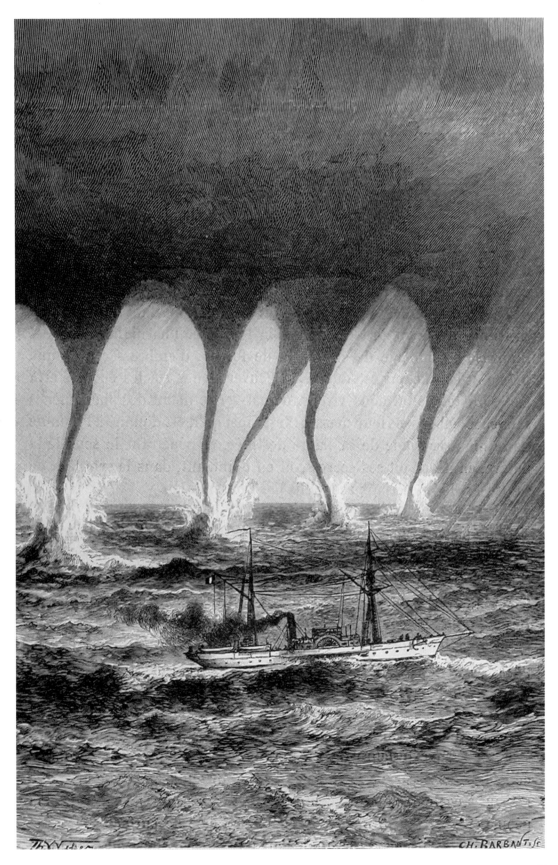

Th. Weber CH. BARBANT sc

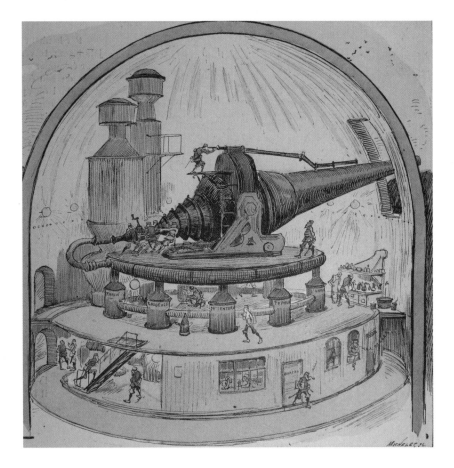

La Guerre au Vingtième Siècle, 1887
La Vingtième Siècle, 1883
Albert Robida

French illustrator, Albert Robida, combined humour with an undercurrent of foreboding, in a trilogy of prescient futuristic books published in the last two decades of the 19th century. He anticipated social advancements in the status of women, public transport and the quality of prisons; alongside improved mass killing machines, a polluted atmosphere and environmental destruction. His books were populated with imagined technologies and gadgetry – including illustrations of 'television' and 'videoconferencing' – but he seemed to suggest in his writing that there was no real progress ahead in the quality of life for the people. Instead, there would be a continual need to adapt to a perpetual onslaught of unnecessary new devices. Robida's ambiguous portrayal of a *dys*topian utopia suggests that he can be cast as either a luddite or a technophile, depending upon your point of view. [The third book in the series was called *La Vie Électrique* (Electric Life) from 1892].

– – –

THE ROBIDA ASSOCIATION FOR THE FUTURE
http://www.robida.info

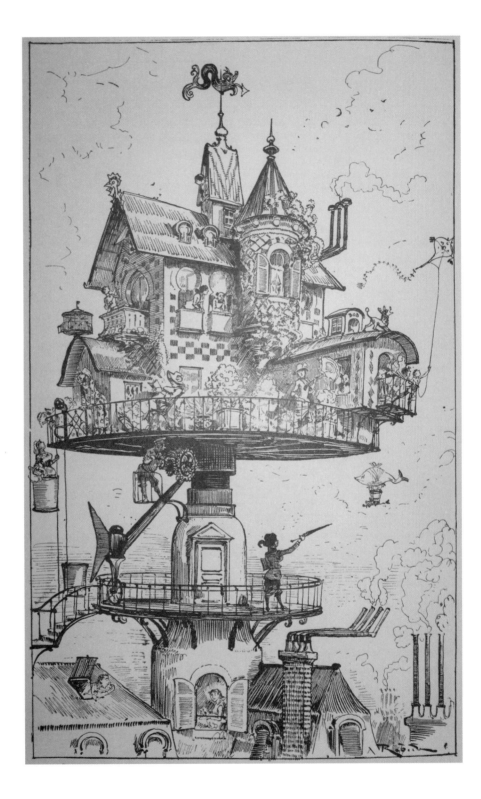

Münchner Kasperl-Theater
Lothar Meggendorfer, 1879

Lothar Meggendorfer began his illustrating career in Munich providing drawings for a number of satirical magazines. However, the main focus of his artisic output turned to children's books after he successfully constructed a pop-up book for his son. He went on to illustrate more than one hundred children's books, the majority incorporating innovative hinge, panorama, tab slide, rivet and revolving plate design elements that are still highly prized today. The images shown here are from one of Meggendorfer's traditional books that portray the hand puppet character of Kasperl (Kasper). This is the German equivalent of Punch from Punch & Judy, or Punchinello/Pulcinella from that richly diverse seam of satirical European illustration, theatre and puppetry tradition, the 15th century *Commedia dell'Arte*.

– – –

UNIVERSITY OF BRAUNSCHWEIG DIGITAL COLLECTION
http://www.digibib.tu-bs.de

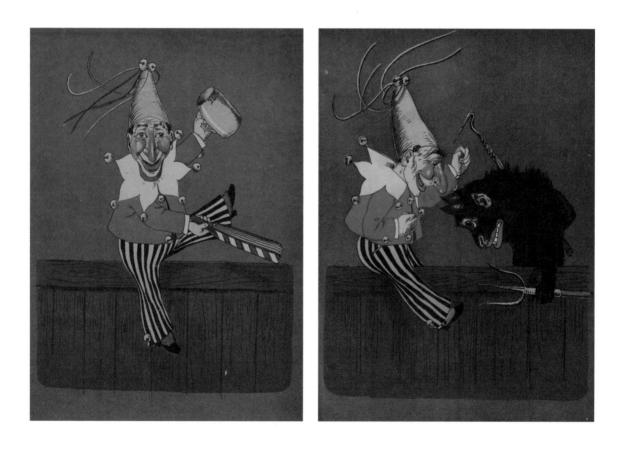

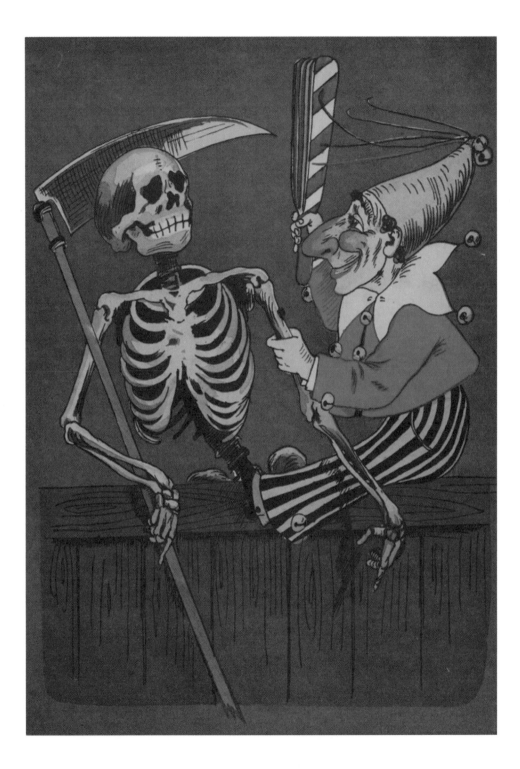

Pl. VII.

Collectanea de Rebus Hibernicis
Charles Vallancey, 1786

*Tortures, c.*1800

Uncharacteristically for a nation that produced one of the greatest of all illustrated works – *The Book of Kells* – there seems to be a relative dearth of historical illustrated book images online from or about Ireland. Noteworthy for their appearance are a selection of engravings from the 1770-1804 series, *Collectanea de Rebus Hibernicis*, by Charles Vallancey, an English antiquarian and philologist, sent to Ireland as Chief Military Surveyor. He was primarily interested in documenting the surviving artefacts and monuments from ancient times. However, Vallancey also used this historical survey as evidence in support of romantic theories he held about Phoenician origins for the settlement of Ireland and a Semitic background to the language. Although his ideas and documentation methods have been widely criticised and largely debunked, they held currency up until the early 20th century. Joyce was aware of this Mediterranean theory of the origin of western civilisation, and Vallancey's writings were no doubt a note of encouragement for overlaying Homeric myths onto a Jewish protagonist's wandering about the Dublin of *Ulysses*. The other image here is from an anonymous illustration series entitled *Tortures*, a broadside pamphlet showing the fate of Irish rebels.

– – –

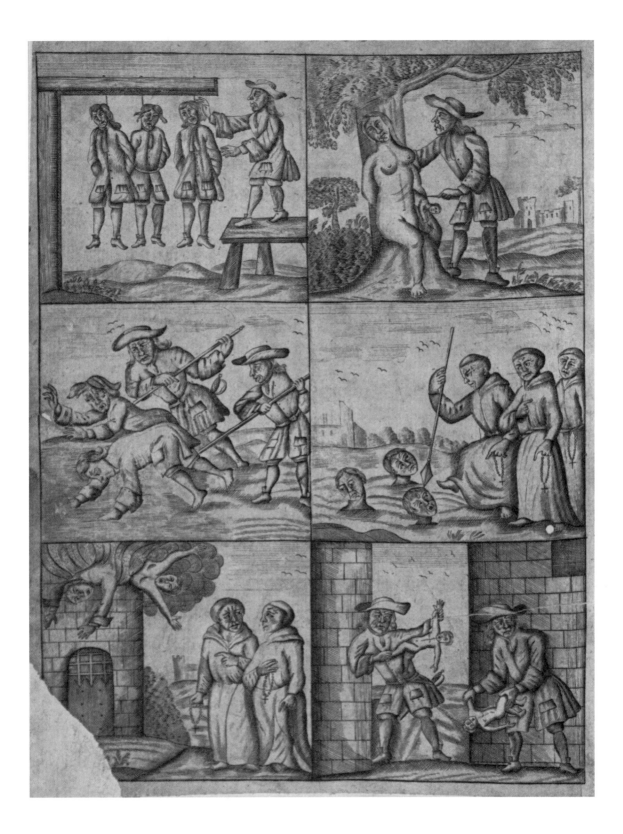

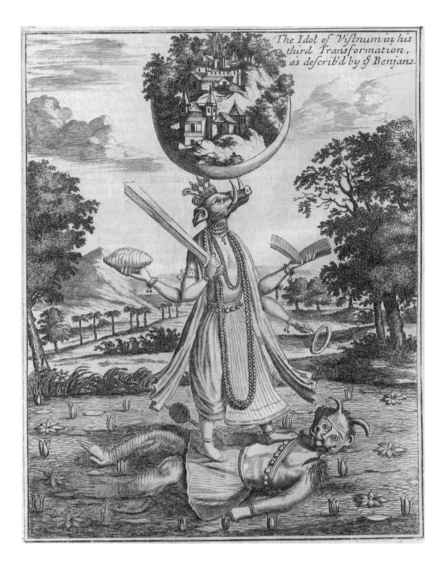

The Idol of Vistnum in his Third Transformation and
The Removal of the Mount Meeperwat
Jacob van Meurs, 1672

Early modern travel writing was unquestionably the most
diverse genre of literature. Newly discovered
ethnographic, navigational, commercial, biological,
military and cartographic information from far flung
places like Asia was presented to an enthralled European
audience. Collections of Jesuit missionary letters and
reports gradually gave way to more formal histories and

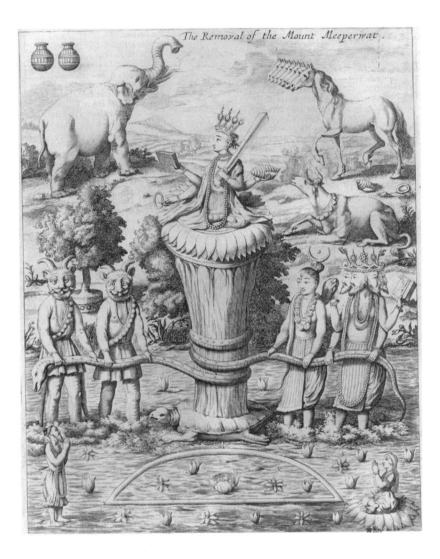

The Removal of the Mount Meeperwat.

secular accounts from traders, explorers and scholars. These works were often illustrated with engravings, both factual, and fanciful, and many of the accounts and drawings were recirculated through translation, borrowing and reinterpretation. By the late 17th century, travel anthologies became an attractive printing venture for those hoping to profit from the widening interest in exotic cultures during the early days of The Enlightenment. In 1704, the Churchill brothers published the very successful four volume compilation, *A Collection of Voyages and Travels*, which included original and translated travel works. The engravings of Hindu mythology here are believed to be by Jacob van Meurs and they accompanied Olfert Dapper's record of interviews with Dutch sea captains and merchants who had visited India.
(see also page 41)

(see also page 41)

– – –

WORLD CIVILIZATIONS IMAGE REPOSITORY,
WASHINGTON STATE UNIVERSITY
http://www.wsulibs.wsu.edu/holland/masc/xworldciv.html

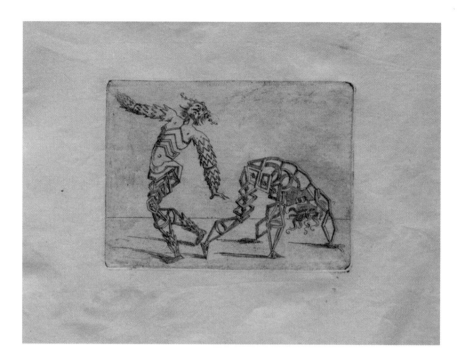

Bizzarie di Varie Figure
Giovanni Battista Braccelli, 1624

Giovanni Battista Braccelli was an obscure Florentine artist who produced an enigmatic series of nearly fifty etchings for his 1624 suite, *Bizzarie di Varie Figure*. The paired acrobatic characters appear through the book to be fashioned out of random household and mechanical bric-a-brac such as plates, screws, rags, geometric shapes and even tennis rackets. Although associated with the tradition of mannerist grotesques, Braccelli's playfully stylised figures were true originals. They are more closely connected to the cubist and surrealist movements of the 20th century than with any contemporary influences, except perhaps as parody. The capricious forms resist a single, or even necessarily, a simple interpretation. As human simulacra, they evoke a correspondence with puppetry, dance and pantomime scenes, and they have even been touted as precursors to the man-as-machine cybernetic culture of more recent times. For whatever reasons after it was published, *Bizzarie di Varie Figure* drifted into a mysterious stream of *esoterica* known only to a select minority of artists and bibliophiles (Horace Walpole noted in his copy in the 1700s that the author had a 'wild imagination') and wasn't rediscovered and republished for a wider audience until the mid-20th century. Consequently, there are less than ten original copies known to exist and only two of these are complete.

– – –

LESSING J. ROSENWALD COLLECTION, RARE BOOK & SPECIAL COLLECTIONS DIVISION, LIBRARY OF CONGRESS
http://www.loc.gov/rr/rarebook/rosenwald.html

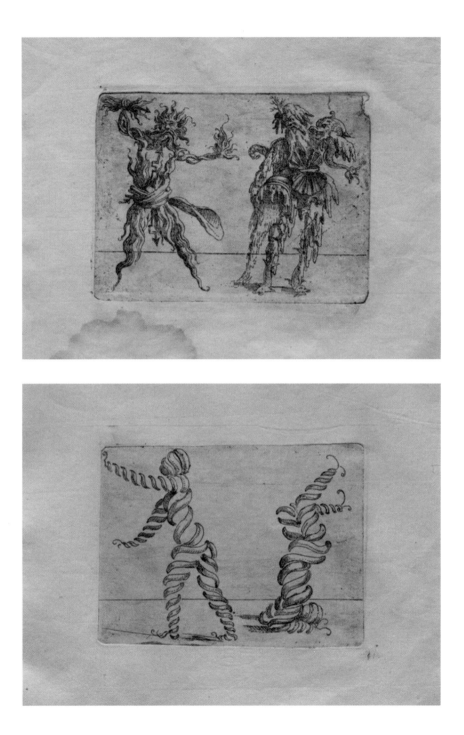

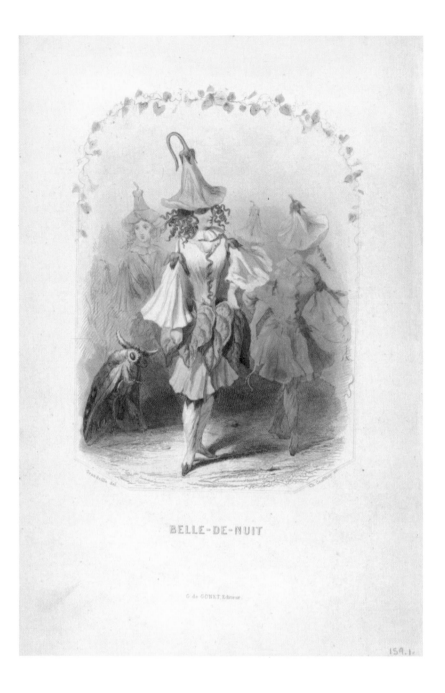

BELLE-DE-NUIT

G. de GONET, Éditeur

159.1.

Les Fleurs Animées
J.J. Grandville, 1847

In his relatively short life, 19th century French caricaturist, J.J. Grandville (pseudonym of Jean Ignace Isidore Gérard), created about 3,000 lithographs, engravings and prints. These encompassed political and topical magazine satires, and book illustrations for a range of classics such as *Robinson Crusoe*; but the print suites and books he produced from his own fertile imagination ensured his lasting fame. Humorous anthropomorphic fantasy caricatures – clothed animals in satirical human dramas or dream like botanical-human composites – were chief among his popular lithographs. His artistic output grew darker later on, and after the death of a couple of his children, Grandville himself died in an asylum in 1847, aged forty-four. He had by then written his own epitaph: 'Here lies Grandville; he gave life to everything and made everything move and speak. The one thing is, he didn't know how to make his own way'.

– – –

MISSOURI BOTANICAL GARDEN LIBRARY
http://www.botanicus.org

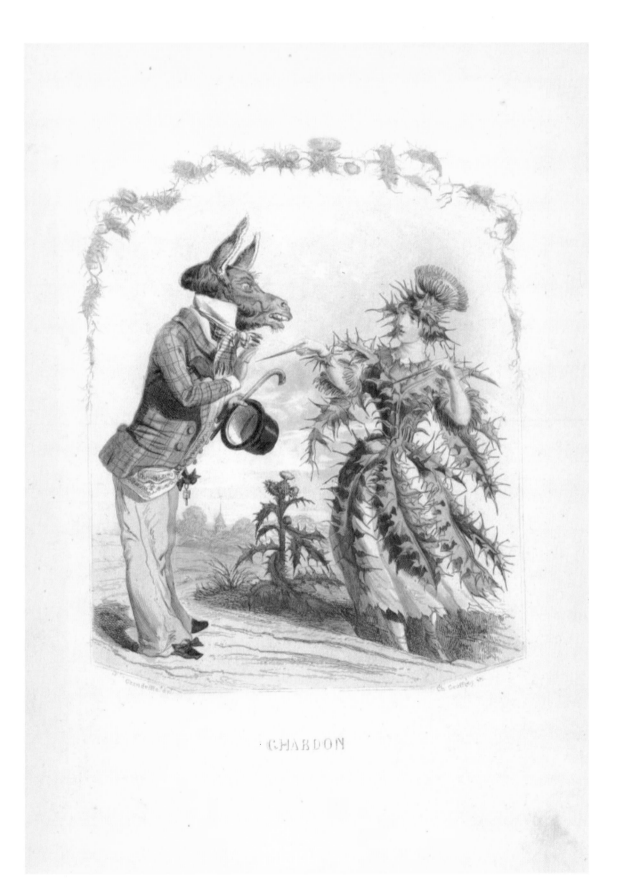

CHARDON

TABAC.

C. de GONET, Editeur.

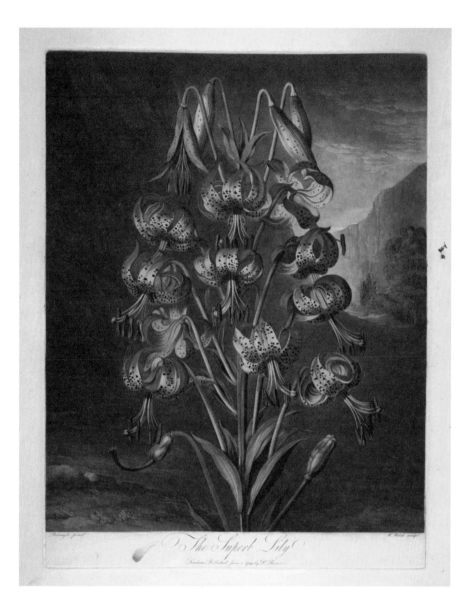

The Superb Lily
Robert John Thornton, 1807

Robert John Thornton's ambitious *Temple of Flora* was the illustrated third volume in an ultimately incomplete botanical homage to the naturalist, Carl Linnaeus. The finest artists and engravers of the day were directed to favour pictorial embellishment over realism, producing one of the most exquisitely beautiful *florilegia* ever crafted, but with little in the way of direct scientific value.

The enterprise sent Thornton bankrupt, as changing tastes and a war intervened to limit the immediate popularity of the series. Thus, only thirty three of the proposed seventy mezzotint and stipple engravings were ever made.

– – –

MISSOURI BOTANICAL GARDEN LIBRARY
http://www.botanicus.org

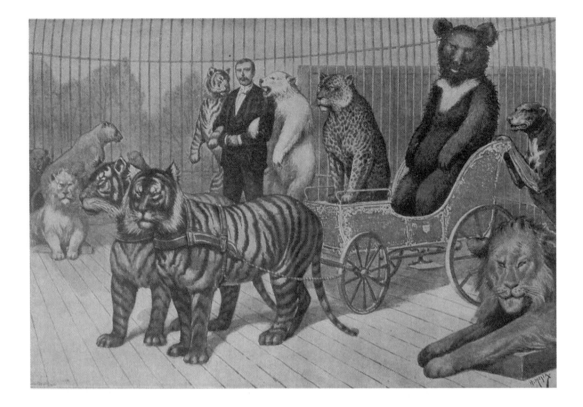

Becoming accustomed to a cage of wild animals, 1895
Trapped in quicksand, 1910

Overleaf:
Suicide at the Arc de Triomphe, 1898
*Rescue of Mademoiselle Dudlay from the fire
at Théâtre-Français*, 1900

Anonymous

For eighty-one years until 1944, the French publication,
Le Petit Journal, was among the most popular daily
newspapers in the country, with average sales of over a
million copies at its peak. Strict government censorship
established an apolitical editorial policy and the paper
inclined towards a sensational reporting culture.
Improvements in photochromic machine printing led to
the inclusion of a weekly illustrated colour supplement
(*Le Petit Journal Illustré*) which remains an idiosyncratic
record of the times. The specific subjects of the dramatic
illustrations presented here were no doubt of topical
interest when they were published, but were mostly
resistant to discovery of background context.

– – –

LE PETIT JOURNAL
http://cent.ans.free.fr

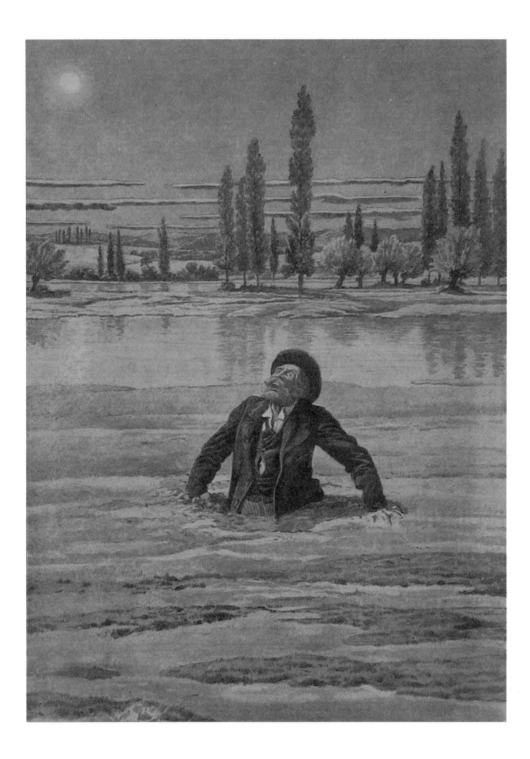

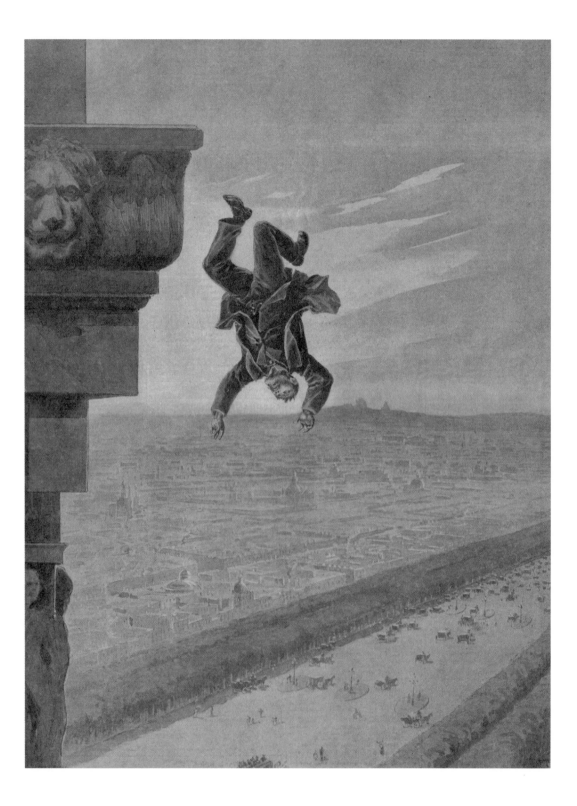

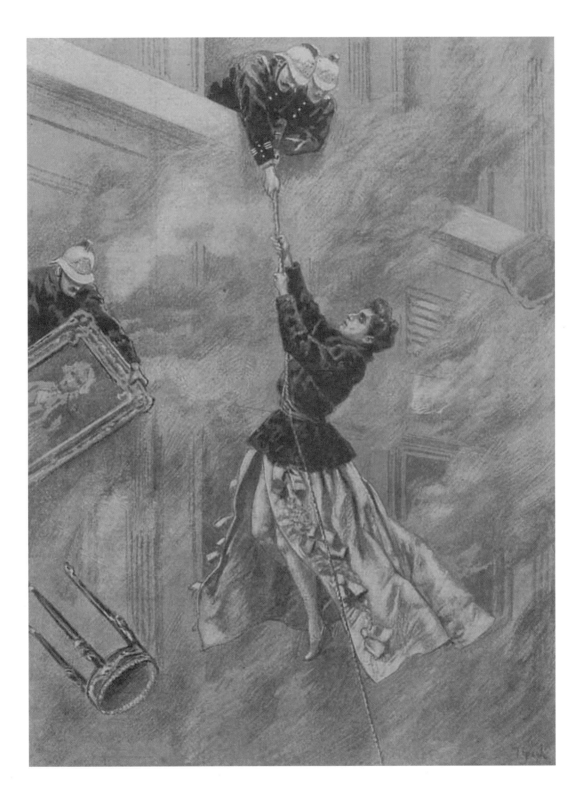

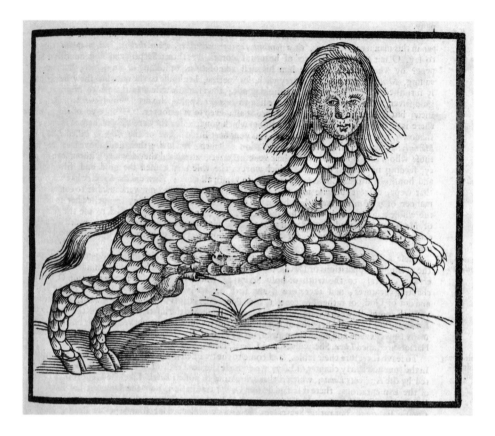

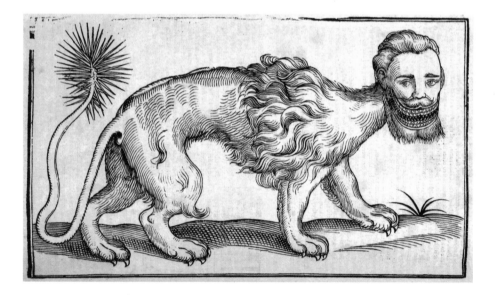

The History of Four-Footed Beasts and Serpents
Edward Topsell, 1658

British cleric, Edward Topsell, was neither a traveller nor a natural scientist, yet his zoological texts from the early 17th century presented a summary of real and imaginary animals (thought real at the time) known since antiquity. Topsell studied the available literature and mythology and relied heavily on Konrad Gesner's *Historiae Animalium* from the 1550s to deliver what are essentially transition works, somewhere between fanciful Medieval beliefs and an emerging scientific rationalism. Among Topsell's many illustrations (most were appropriated from Gesner), the fabulous creatures displayed here are: the child-eating

Lamia, with a dragon-scaled body and the head of a woman; the very toothy *Mantichora*, (another human flesh *aficionado*) with a stinging tail, the body of a lion and the top half of a man's head; and the seven headed *Hydra*, which Topsell, in a notional attempt at logical validation, only includes because he was reliably informed that one existed at the Duke's Treasury in Venice.

– – –

UNIVERSITY OF HOUSTON LIBRARIES SPECIAL COLLECTIONS
http://info.lib.uh.edu/sca/index.html

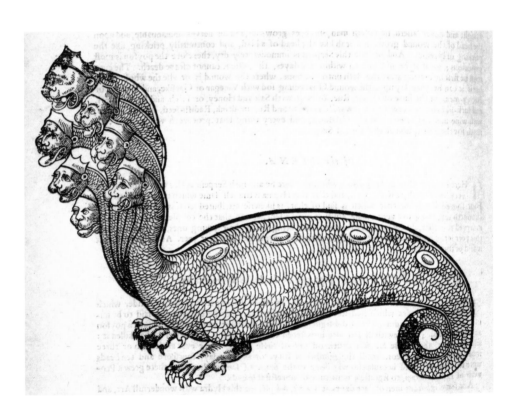

Le Chef ou Prince des mauvais esprits auquel
les Formosans sacrifient
George Psalmanazar, 1705

One of the great literary frauds of the 18th century
involved a book said to be a native's account of his
Taiwanese homeland. *An Historical and Geographical*
Description of Formosa by an infamous character known
as George Psalmanazar was first published to popular
acclaim in 1705. But Psalmanazar had actually invented
the history, language, writing script and religion of 'his
people'. Any occasional relationship to the truth came, no
doubt, from his seeing the scant details in Jesuit
missionary letters and maps that had by that stage filtered
through to Europe. His undoing came from making
untenable errors, such as alleging the sacrifice of 18,000
babies a year, which wasn't statistically plausible, and in
repeated failures at translating the same passage into
his imaginary script. But the sensational stories of
cannibalism, polygamy and sacrifice meant profitable
returns were taken before his credibility had been at least
partially shredded in front of the Royal Society. His true
identity was never revealed, but Psalmanazar was shamed
enough to admit his guilt in a work published following his
death. Thus we have here an engraving of a mythological
devil from an imaginary religion out of a confabulated
narrative – appropriately housed in the *Fantastic in Art*
and Fiction Collection.

– – –

DIVISION OF RARE AND MANUSCRIPT COLLECTIONS,
CORNELL UNIVERSITY LIBRARY
http://fantastic.library.cornell.edu

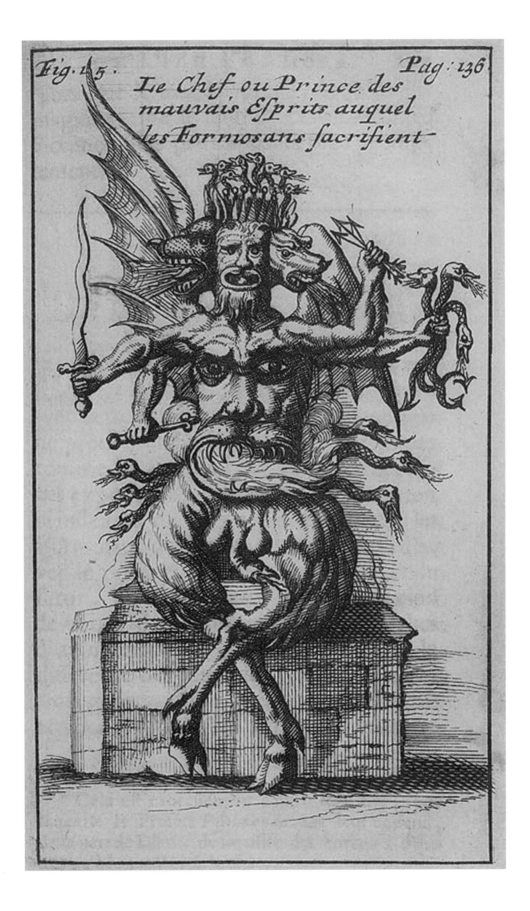

Fig. 15.
Pag. 136

Le Chef ou Prince des
mauvais Esprits auquel
les Formosans sacrifient

ITALY.

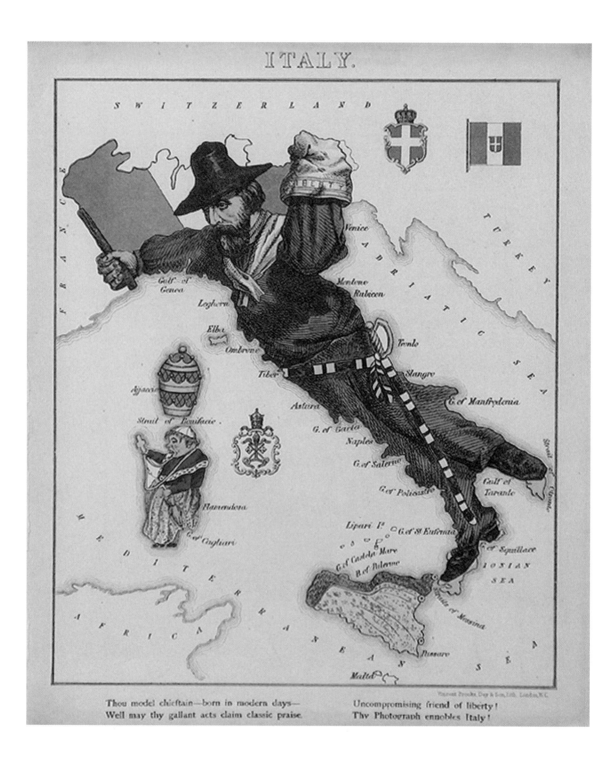

Thou model chieftain—born in modern days—
Well may thy gallant acts claim classic praise.

Uncompromising friend of liberty!
Thy Photograph ennobles Italy!

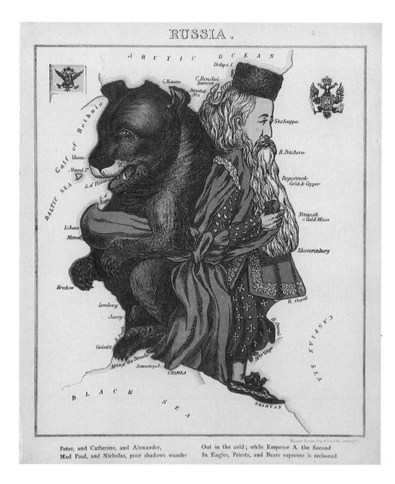

Geographical Fun
William Harvey (Aleph), 1869

The story goes that the brother of a certain fourteen-year-old girl was sick in bed and needed cheering up. The enterprising girl found an image of Punch (from Punch & Judy) riding a dolphin which she transformed into a comical map of England. This became the inspiration for *her* series of a dozen maps of European countries made out of stereotype caricatures and published in 1869, along with a short descriptive verse for each picture by the author, Aleph. In the introduction, Aleph tells of his hope that the amusing drawings will encourage young people to become interested in geography. Whether or not a fourteen-year-old girl was capable of developing all the sophisticated political and caricatural nuances portrayed is perhaps a moot point. Aleph was later revealed as the pseudonym of the journalist, William Harvey. Russia is formed by Tsar Alexander II standing back-to-back with a brown bear; Scotland is formed by the kilt-clad piper 'struggling through the bogs'; and mainland Italy is represented by the revolutionary patriot, Giuseppe Garibaldi, waving the flag and wearing the Cap of Liberty, while standing tall over the diminutive opponent of Italian unification, Pope Pius IX, as Sardinia.

– – –

THE MAP HOUSE OF LONDON
http://www.themaphouse.com

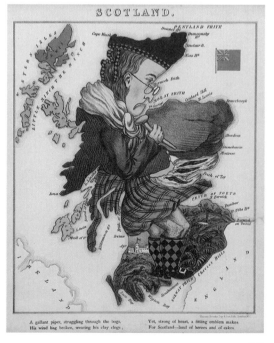

Kufic script animals
Anonymous, 19th century

Arabic scripts have an intrinsic flexibility making them
perfect vectors for a diverse range of calligraphic
expression. Their curvilinear nature and malleability
inspired radical experimentation throughout history, but it
wasn't until about the 15th century, when the restrictions
on religious iconography were loosened, that artists in Iran
began to conjure shapes such as birds and animals from
the scripts. This *figural* or *zoomorphic* calligraphy has
traditionally incorporated text from the Koran. In the
process of artistic abstraction of the letters into visual
word forms, new layers of nuanced meaning may develop,
where knowledge of the language is undoubtedly required
for a complete understanding. The lion, bird and elephant
images here are thought to be from a Persian scroll with
Kufic script from the 19th century.

− − −

PROFESSOR FRANCES PRITCHETT, COLUMBIA UNIVERSITY
http://www.columbia.edu/itc/mealac/pritchett

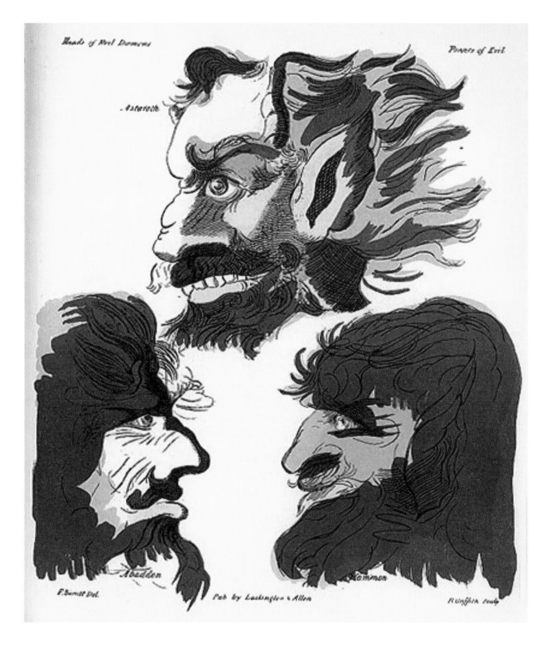

Heads of Evil Demons – Powers of Evil
Francis Barrett, 1801

Occult teacher, Francis Barrett, hoped to revive interest in the esoteric arts with the publication of *The Magus or Celestial Intelligencer*. It remains a primary source for ceremonial magic, combining detailed knowledge about alchemy, astrology and the mystical Kabbalah, and includes a supplement with biographies of the major adepts from history. Barrett's tome was more of a compilation than an original work, but he translated some obscure source material, particularly from Medieval German alchemist, Cornelius Agrippa. It was thought that

Barrett spent years researching the work. Prior to any material being included, he first subjected the various theories to certain tests that had to be 'substantiated by nature, truth, and experiment'. Needless to say, *The Magus* was for many years actively suppressed, and rare library copies were often hidden from the public.

– – –

RARE BOOKS AND SPECIAL COLLECTIONS,
UNIVERSITY OF SYDNEY LIBRARY
http://www.library.usyd.edu.au/libraries/rare

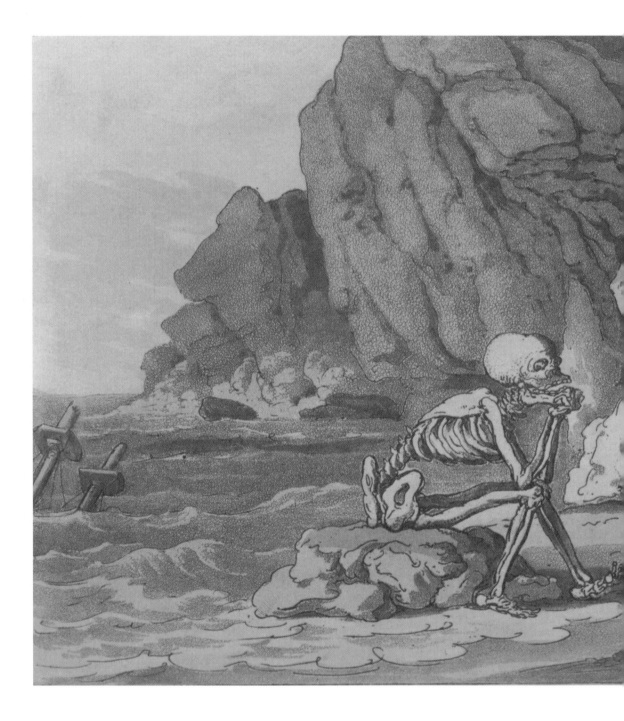

English Dance of Death
Thomas Rowlandson, 1815

The *danse macabre* theme, possibly derived from 14th century morality plays, first appeared in visual form as a Parisian cemetery mural in the early 1400s.
The traditional motif of a dancing skeleton leading unsuspecting victims to their death was reinterpreted across Europe for more than four centuries. While the allegorical imperative was to inspire a penitent life,

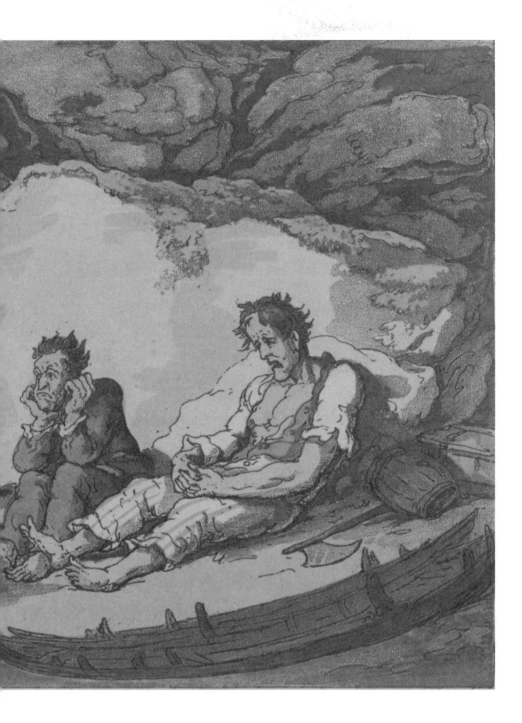

illustrators augmented the designs to include social and political subject matter reflective of their own time and locality. For Thomas Rowlandson it was an opportunity to exercise his penchant for dark humour in one of the later interpretations of the genre. We observers of his *English Dance of Death* aquatint engravings are enlisted as co-conspirators, experiencing a moment of *schadenfreude,* as we watch the comical frozen details of a hapless victim's fatal undoing. Death always has the last laugh of course. Not even the insipid accompanying verse by William Coombe could prevent the two volume set from becoming popular. Rowlandson was one of the great draughtsmen caricaturists of the late Georgian period and, together with James Gilray, made up the backbone of the golden age of illustration in Britain.
(see also pages 80, 155)

– – –

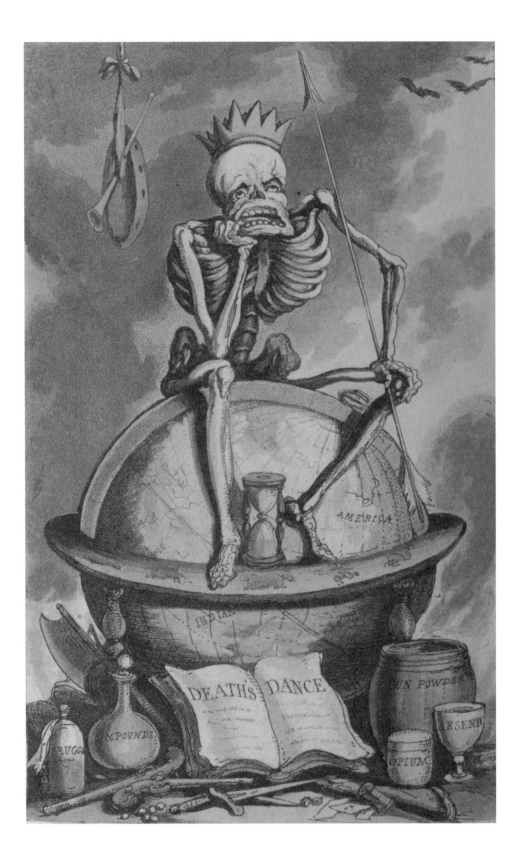

THE ENGLISH Dance of Death

Pallida Mors æquo pulsat pede pauperum tabernas,
Regumque turres. Hor. Lib. 1. Od. 4.

Vol. 1.

LONDON, Published March 1. 1816 by R. Ackermann 101. Strand.

115

Beschreibung und Abbildung eines
ungebornen Elephanten
Eberhard Zimmermann, 1783

German biologist, geographer and travel writer, Eberhard
Zimmermann, is best remembered for his series of
publications on the geographical distribution of mammals.
The extraordinary engraving here comes from a short and
rather obscure related treatise published in 1783,
Beschreibung und Abbildung eines ungebornen
Elephanten (Description and Illustration of an Unborn
Elephant). The serene picture of the elephant foetus is
the only illustration in the book.

– – –

UNIVERSITY OF BRAUNSCHWEIG DIGITAL COLLECTION
http://www.biblio.tu-bs.de

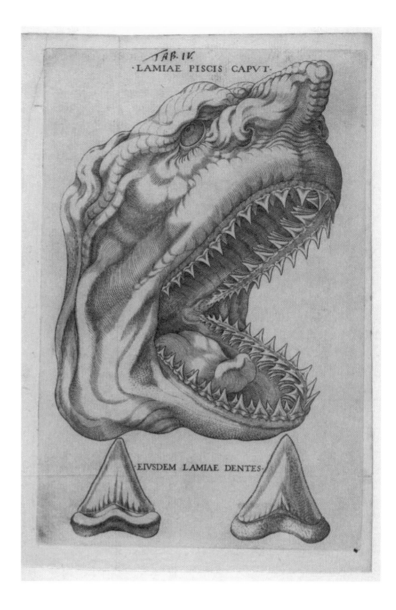

Canis Carchariæ Dissectum Caput
Niels Stensen, 1667

Pliny the Elder speculated in the first century that the curious teeth-like objects, often found in the mountains of Malta, had fallen to earth during a lunar eclipse. Popular legend contended that St. Paul had visited the island and cast snakes into a fire, producing magical tongue-stones (*glossopetræ*) which could protect against poisoning. Their true nature was explained in 1666 when the respected Danish anatomist, Nicolaus Steno (Niels Stensen), in the employ of the Medici family in Florence, examined a large shark caught in nearby Livorno. He concluded that as the *glossopetræ* were similar to, but not quite the same as, the shark's teeth, they therefore belonged to an extinct shark species, and that the sea must have covered the mountains in earlier times.

This aroused Steno's interest in both fossils and geology. When he published his results in the following years, he virtually established palaeontology as a scientific discipline and he also made significant contributions to our understanding of stratified rock formations. The dissected shark image first appeaed in *Canis Carchariæ Dissectum Caput* in 1667. His previous anatomical studies had yielded similarly important discoveries. But despite these incredible achievements, Steno walked away from science to train for the priesthood, and was appointed as a Bishop in 1677. He lived the rest of his short life in austere self-denial and was said to have been severely emaciated at the time of his death. He was beatified by the Catholic Church in 1988 as a first step towards becoming a saint.

– – –

COPENHAGEN UNIVERSITY LIBRARY
http://www.kb.dk/en/kb/nb/ha/index.html

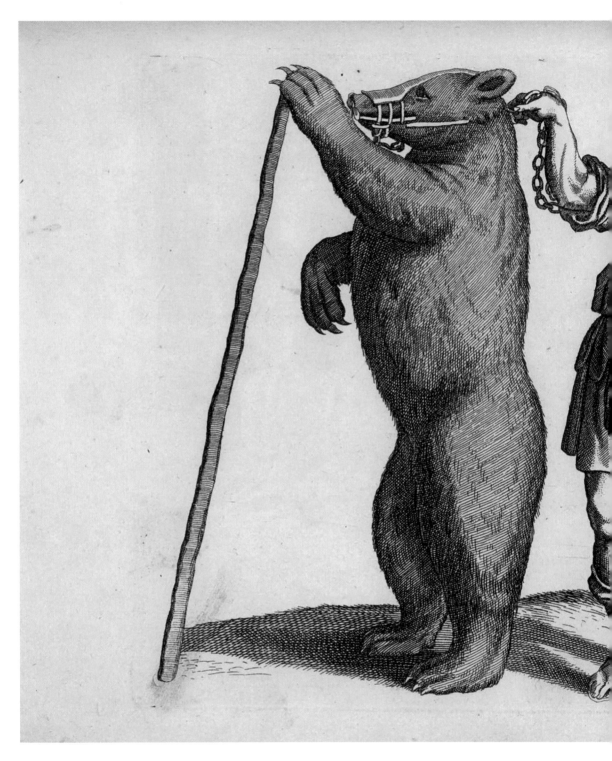

A Description of the Nature of Four-Footed Beasts
John Johnston, 1668

The massive *Historië Naturalis* series from the 1650s by
Polish physician, Johannes Jonstonus, (John Johnston)
was another of those transition works straddling Medieval
myth and modern scientific compendium. Johnston

attempted to objectively describe all known creatures in an
encyclopaedic work, copiously illustrated with copperplate
engravings from the print shop of Matthïus Merian. The
work contributed to the emerging educational approach of
scientific publications and was no doubt influenced by
Johnston's friendship with the 'father of modern
education', Jan Comenius. Johnston relied heavily on

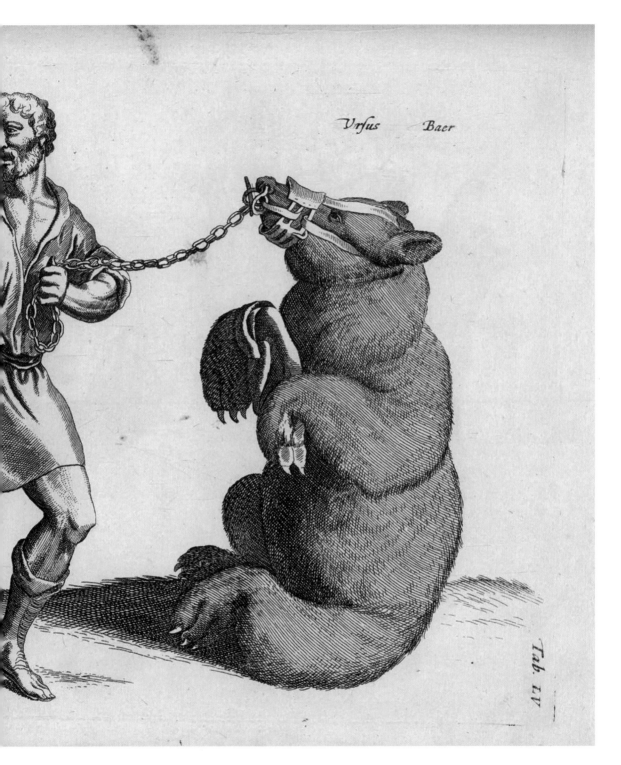

Vrsus *Baer*

Tab. LV

established natural science authorities (Aldrovandi, Pliny, Gesner, Seneca) and where, for instance, the behavioural descriptions of the bear seen here seem mostly plausible when read today, an equal amount of the text is given over to folkloric medicinal remedies, in which the various parts of the bear could be used. The whole series of books was presented to the then Japanese Emperor, and remained the only source on western natural history in Japan for a century.

– – –

HISTORY OF SCIENCE AND TECHNOLOGY COLLECTION, UNIVERSITY OF WISCONSIN
http://digicoll.library.wisc.edu/HistSciTech

119

Sein Denkmal.

Blicke in die Vergangenheit und Zukunft beim Anfang des Jahres 1814.

Blicke in die Vergangenheit und Zukunft
(Views of the Past and Future) and
Das ist mein lieber Sohn, an dem ich Wohlgefallen habe
(Thou Art My Beloved Son, In Whom I Am Well Pleased)
Anonymous, 1814

At the beginning of the 19th century, a unique array of political and artistic circumstances conspired to produce one of history's great targets for the caricaturist's pen in the figure of Napoleon Bonaparte. Although subversive cartoons were hardly a new phenomenon, the military campaigns threatening Europe and the Middle East, combined with the megalomanic and self-promotional tendencies of the great man himself and the widespread belief that an invasion of England was imminent, fuelled an industry of satirical illustrators led by James Gilray. English anti-Napoleonic caricatures in prints, newspapers and handbills were very efficient in arousing national patriotism, and the thematic and stylistic elements significantly influenced the popular illustrative response in Europe. The rare German prints seen here date from the year prior to Napoleon's eventual defeat at Waterloo. They are fairly vicious in their symbolism, casting Napoleon as the devil's spawn and suggesting a legacy built on the deaths of his victims.

– – –

DIVISION OF RARE AND MANUSCRIPT COLLECTIONS,
CORNELL UNIVERSITY LIBRARY
http://rmc-images.library.cornell.edu

Das ist mein lieber Sohn, an dem ich Wohlgefallen habe.

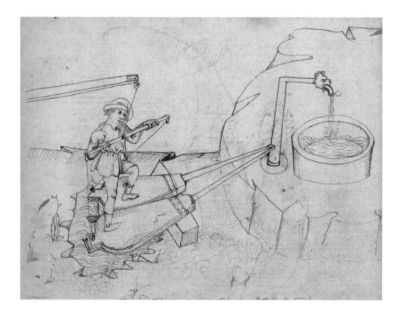

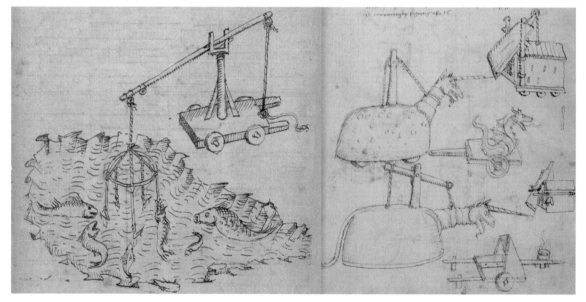

De Ingeneis
Mariano Taccola, 1449

Mariano Taccola was known as the Archimedes of Siena and produced some of the earliest examples of the new illustrated style of engineering and machine manuals, that came into vogue during the Renaissance. Taccola's training as a sculptor honed his drafting skills, and the social realities of Siena – lacking a stable water supply and being in a semi-permanent state of war – provided the

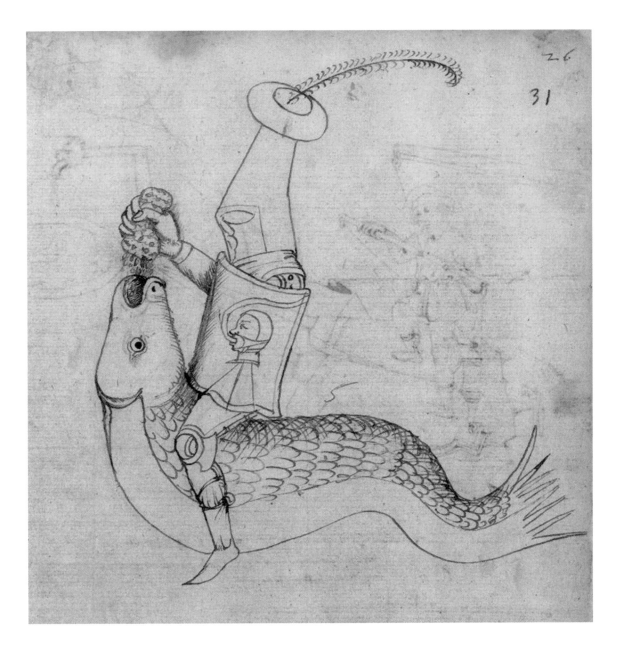

technological subject matter for his imagination. The sketch book images here are details from *De Ingeneis* (The Engines), and Taccola was not averse to including whimsical drawings alongside the more serious creations. He has been variously credited with inventing pumps, bridge building and transmission systems, underwater breathing devices, water and windmill axle mechanisms and, less likely, the trebuchet and catapult. Despite any difficulties we have now in attempting to identify specific inventions by Taccola, his manuals are important for their

documentation of the innovative excellence of the Sienese engineers of the time period. Leonardo da Vinci was known to have viewed some of Taccola's manuscript work prior to sketching his own series of machine technology masterpieces.

— — —

KINEMATIC MODELS FOR DESIGN DIGITAL LIBRARY, CORNELL UNIVERSITY
http://kmoddl.library.cornell.edu/index.php

CUCURBITUS Ier
Costume d'apparat.

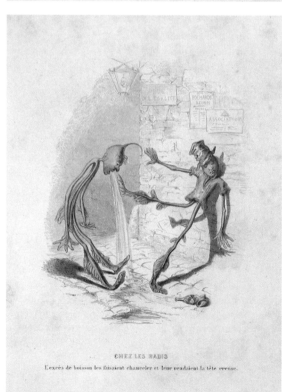

CHEZ LES RADIS
L'excès de boisson les faisaient chanceler et leur rendaient la tête creuse.

L'Empire des Légumes (The Vegetable Empire)
Pierre Amédée Varin, 1851

Overleaf:
Les Papillons – Metamorphoses Terrestres Des Peuples De L'Air (The Butterflies – Terrestrial Metamorophosis of the Air People)
Pierre Amédée Varin, 1852

Pierre Amédée Varin came from a dynasty of French artist engravers going back two centuries and he was a member of the distinguished *École des Beaux-Arts*. For most of his professional life he worked with his brother Eugëne, engraving and painting reproductions and popular prints. It comes as no surprise to learn that in the early 1840s Varin contributed to the J.J. Grandville anthropomorphic series, *Les Fleurs Animées* (see page 96). The influence is fairly obvious in the two series of whimsical prints he created for books published by Gabriel de Gonet.

– – –

PANTEEK ANTIQUE PRINTS
http://www.panteek.com

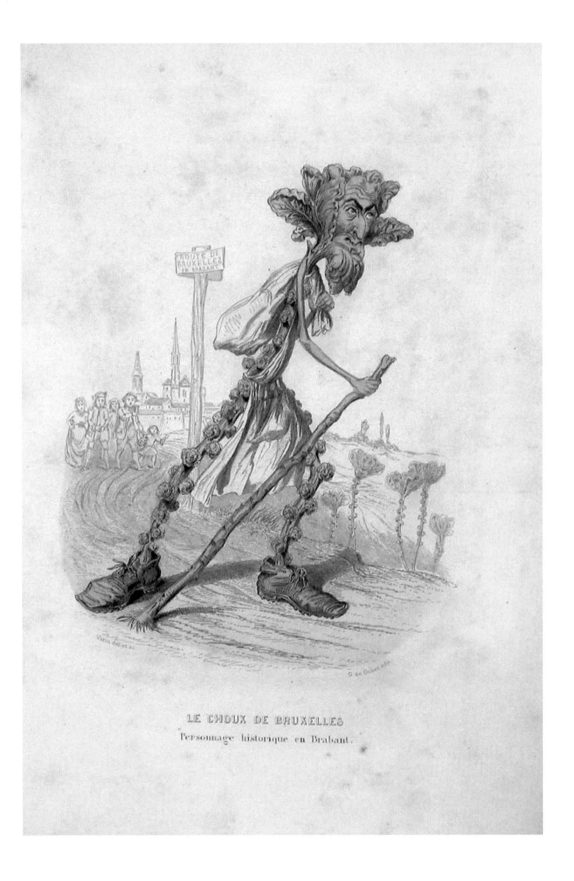

LE CHOUX DE BRUXELLES
Personnage historique en Brabant.

Dans leur course aérienne ils s'effleurèrent des lèvres

Theatrum Cometicum
Stanislaus Lubienietski, 1668

Historically, comets have been regarded in many cultures as harbingers of doom because, unlike other predictable and mappable celestial bodies, comets have tails and appear erratically at seemingly haphazard locations in the sky. Aristotle thought they were eruptions in the upper atmosphere, and it took the whole of the 17th century for science to understand, with any degree of accuracy, their true nature and orbital paths. Stanislaus Lubienietski's *Theatrum Cometicum* (The Comet Theatre) helped establish the study of comets as an astronomical rather than an astrological discipline. Apart from compiling and discussing all historical accounts of comets, Lubienietski's massive work includes engravings of star maps made by many contemporary intellectuals, (Hevelius, Huygens, Kircher and company), who recorded the appearance of a comet from different locations across Europe in 1664–65. *Theatrum Cometicum* therefore inadvertently became an elegant review of the celestial cartographic styles practiced in the 17th century.

– – –

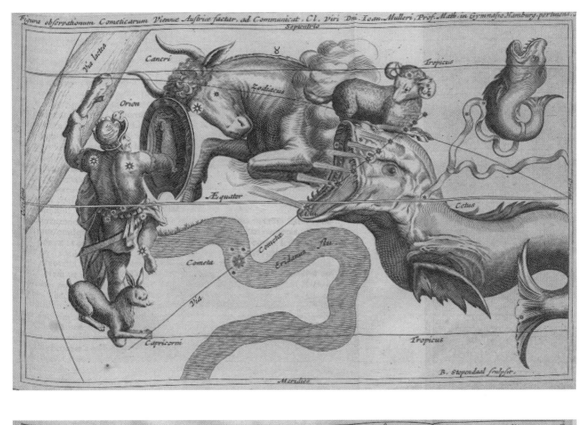

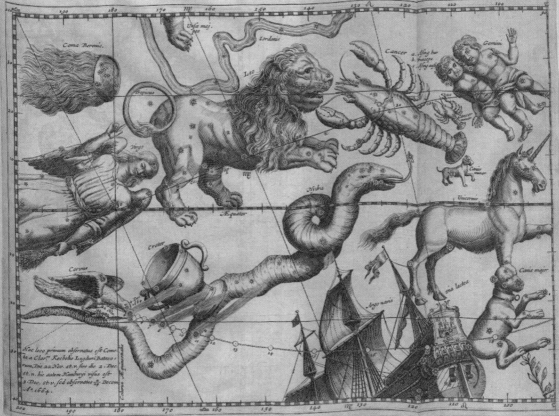

Smoking Construction
Brian McKenzie, 1992

London artist, Brian McKenzie, has been involved in intaglio
printmaking for two decades. His body of work covers a
diverse range of subject matter, from Renaissance-*esque*
costumed figures, fantasy anatomy and zoology, and
mysterious underwater and imaginary environments.
Always there is an exploration of bodily forms. *Smoking
Construction* parodies the toy assembly instruction sheets
found inside chocolate eggs.

— — —

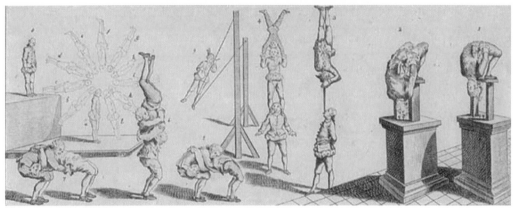

Elementarwerk
Daniel Chodowiecki, 1774

The writings of Jean-Jacques Rousseau during the Enlightenment were the philosophical stimulus for educational reform in Europe. His belief in fostering the natural development of a child was adapted by the educator, Johann Bernhard Basedow, who promoted a school curriculum that balanced a more stimulating learning environment with the need for adequate play and exercise. Basedow published a number of books in which he argued that the teaching environment should be relaxed and friendly, with trained staff each following a similar programme, and that the content should be geared towards the practical and useful over mere indoctrination. The acrobatics image here from Basedow's 1774 manual,

Elementarwerk, is one of a hundred engravings by Daniel Chodowiecki that attempted, in a manner similar to Jan Comenius before him, to display pictorially and descriptively all the necessary knowledge for educating children. Despite the commercial failure of the progressive school, *Philanthropinum*, that Basedow established to demonstrate his techniques, the principles he espoused helped change the nature of educating practices across Europe.

– – –

PICTURA PAEDAGOGICA ONLINE, GERMAN INSTITUTE FOR INTERNATIONAL EDUCATIONAL RESEARCH
http://www.bbf.dipf.de/virtuellesbildarchiv/index.html

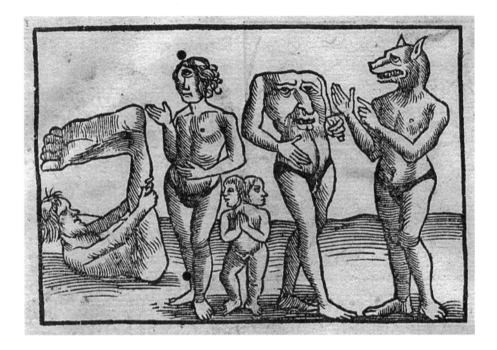

Cosmographia
Sebastian Münster, 1544

Sebastian Münster was regarded as the leading German
cartographer of the first half of the 16th century, but his
academic interests stretched to Hebrew scholarship,
mathematics, cosmography and linguistics. Following the
tradition of Schedel's *Nuremberg Chronicle*, Münster
audaciously sought to compile something of an
encyclopaedic record of the known (and imagined) world,
in a six volume work called *Cosmographia*. It was first
published in 1544 and more than forty editions were
issued in the following century, giving an indication of its
popularity and far reaching influence. Münster had earlier
intended to compile a geographic survey of Germany, and
he enlisted the help of regional scholars who supplied
cartographic and descriptive summaries about their local
areas. To this core material was added many new maps
and information collected from Münster's wide-ranging
travels and reading of contemporary authors, together with
extensive excerpts from the traditional natural history
works of Pliny, Strabo, Aristotle and Ptolemy. Several
hundred woodcut illustrations were assembled, among
them many exceedingly peculiar images, such as the one
shown here. According to folklore, there was a race of
monsters inhabiting the edge of the world which Pliny had
located in the mountains of India. The inclusion of dog
headed cannibals, giant cyclops and chimeric beastmen
no doubt helped to publicise Münster's book.

– – –

PROFESSOR FRANCES PRITCHETT,
COLUMBIA UNIVERSITY
http://www.columbia.edu/itc/mealac/pritchett

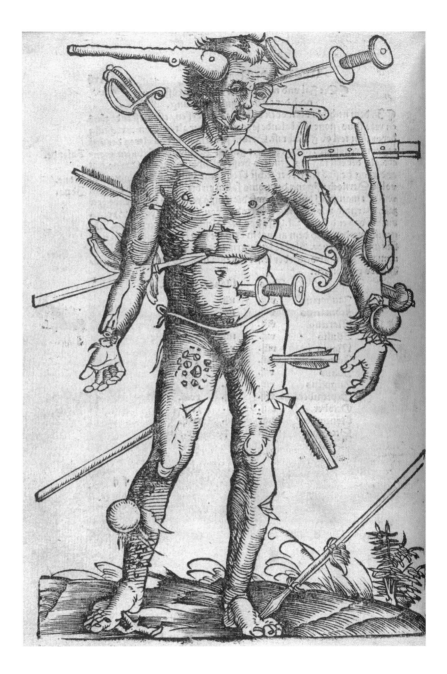

Wound Man
Johann Wechtlin, 1517

Hans von Gersdorff worked for forty years as a military
surgeon and is believed to have performed two hundred
amputations despite having no formal training. In his
1517 book, *Feldtbüch der Wundtartzney* (Field Book of
Wound Surgery), von Gersdorff described in detail the
extraction of bullets and arrows, the setting of fractured
bones, the use of cautery and tourniquets in bleeding

control, and of course, how to remove a limb and cover
it with a pig's bladder. The array of striking woodcut
illustrations by Johann Wechtlin, including the famous
Wound Man shown here (which was actually an elaboration
of a less intricate 1497 version), ensured that the book was
very popular, widely quoted, and often plagiarised.

− − −

HISTORICAL ANATOMIES ON THE WEB,
US NATIONAL LIBRARY OF MEDICINE
http://www.nlm.nih.gov/exhibition/historicalanatomies/home.html

Le Concert
Louis-Lèopold Boilly, c.1800

Louis-Lèopold Boilly emerged untrained from provincial France into post-Revolution Paris as a fully developed artist, albeit with an initial taste for risqué frou-frou. Under a threat of imprisonment for obscenity in 1794, Boilly redirected his energies towards recording the everyday scenes of Paris, with meticulous and often amusing portraits of contemporary social types. Frequent showings at the Paris Salon conferred added legitimacy to this modern form of painted satire, but Boilly also produced a number of prints, including the first known French lithograph in 1802. *Le Concert* from the early 19th century, captures the performers mid-note, adding, as Boilly often did, a spectator's dimension to viewing the caricature.

– – –

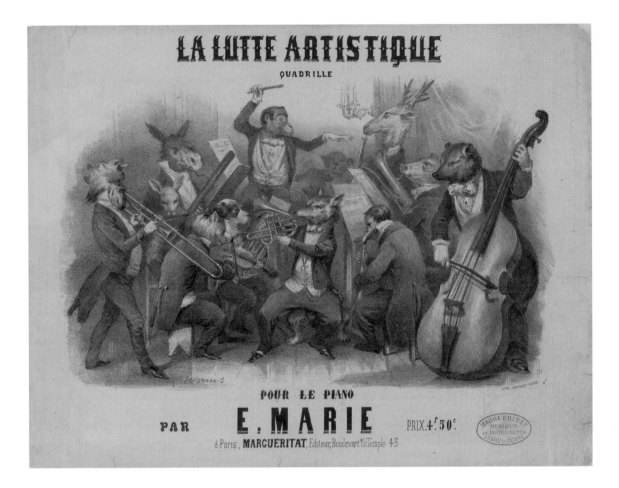

La Lutte Artistique (The Artistic Struggle)
Jules Worm, 19th century

This music cover lithograph is by Jules Worm, a Parisian genre oil painter and illustrator. The piano score is for a quadrille, a popular type of music and dance in the 1800s, that descended from military parade formations and later gave rise to square dancing.

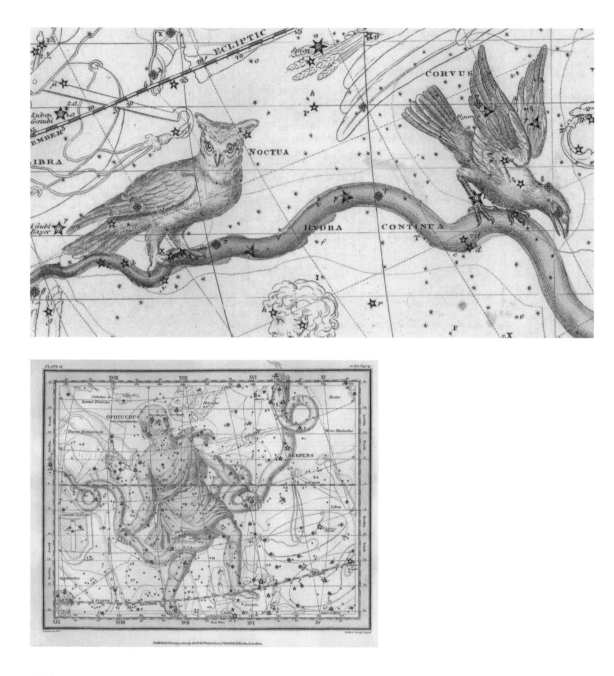

A Celestial Atlas
Alexander Jamieson, 1822

The elegant synthesis of art, mythology and science in the celestial atlas tradition peaked during the two centuries that followed the publication of Johann Bayer's masterpiece *Uranometria*, in 1603. It is generally agreed that three further groundbreaking works were produced in this period by: Hevelius, 1690; Flamsteed, 1729; and Bode, 1801. Each was characterised by significant scientific additions, coupled with exceptionally beautiful illustration styles, and each gave rise to its own branch of impersonator and homage. Amateur British astronomer, Alexander Jamieson, considered of course that his 1822 work, *A Celestial Atlas*

Comprising a Systematic Display of the Heavens, improved upon Johann Bode's immense *Uranographia*, after which it was modelled. Jamieson's atlas was nevertheless a magnificent production in its own right, employing subtle pastel handcolouring and engraved shading to highlight the constellations. It was also the beginning of the end for the golden age of celestial maps, as the scientific need to include an ever expanding profile of newly discovered stars, trumped the artistic convention of accentuating the zodiac mythology.
(see also page 54)

– – –

US NAVAL OBSERVATORY LIBRARY
http://www.usno.navy.mil/library

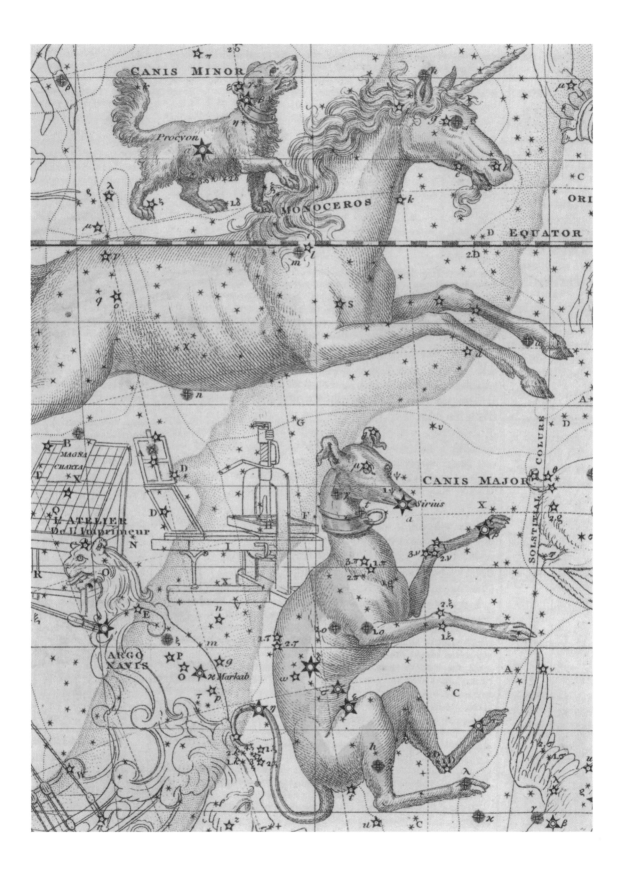

Le Livre des checs Amoureux Moralisés
Robinet Testard, 1496

These mythological figures of Pluto, Venus and Pan are
miniatures from the 1496 illuminated manuscript,
Le Livre des checs Amoureux Moralisés (The Book of
Morals – A Chess Game of Love). The stunning illustration
work was carried out by Robinet Testard, a renowned
manuscript illuminator in the employ of the Count of
Angoulème (father of King Charles I). The manuscript is a
copy of an allegorical love story from 1400 by the royal
doctor, Édvrard de Conty. This, in turn, was greatly inspired
by one of the most famous and influential Medieval books
in France and the prime exemplar of chivalric love,
Le Roman de la Rose, from the 13th century.

– – –

MANDRAGORE MANUSCRIPT COLLECTION,
NATIONAL LIBRARY OF FRANCE
http://mandragore.bnf.fr

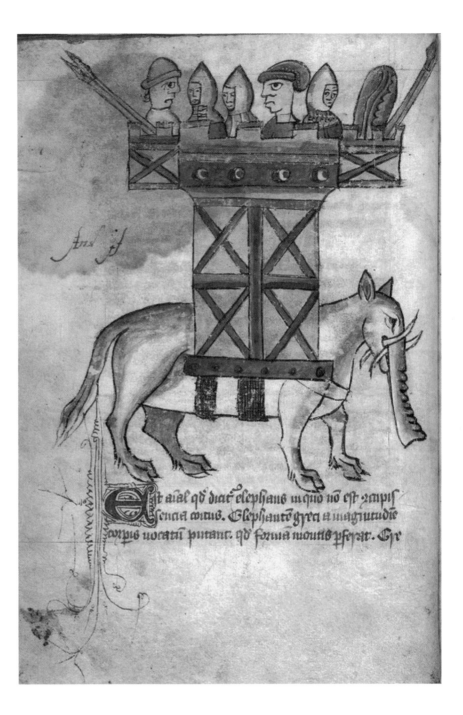

The Bestiary of Anne Walshe
Anonymous, c.1400

The title of this parchment quarto manuscript derives from the practice handwriting found in the margins, by the presumed daughter of an early owner. Textual analysis found the latin variant to be a bastardised Anglicana script, suggesting that the document was produced in England in about 1400. Although based on the *Physiologus*, Anne's bestiary is probably compiled from a number of sources and includes illustrations and descriptions of over one hundred animals (many of which are very humorous either by intent or from a modern perspective). Workers in the scriptorium that created the bestiary had almost certainly never seen an elephant of course, and have given it features such as cloven hooves, from more familiar mammals.

(see also page 52)

– – –

DEPARTMENT OF MANUSCRIPTS & RARE BOOKS,
ROYAL AND NATIONAL LIBRARY OF DENMARK
http://www.kb.dk/en/kb/nb/ha/index.html

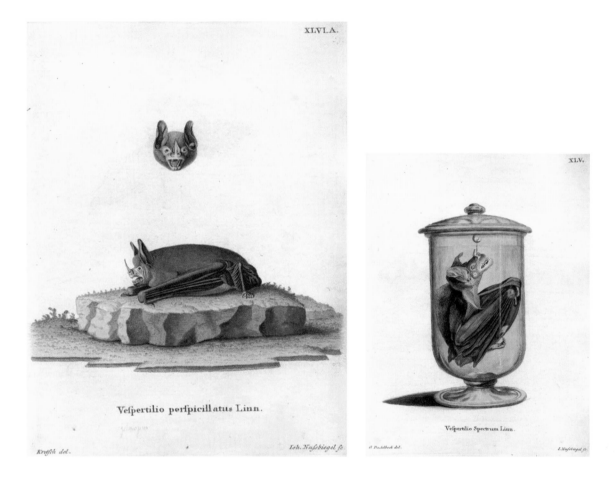

XLVI.A.

Vefpertilio perfpicillatus Linn.

Kreffch del.

Ioh. Nufsbiegel fc.

XLV.

Vefpertilio Spectrum Linn.

G. Paddelbeck del.

I. Nufsbiegel fc.

Die Saugthiere in Abbildungen nach der Natur
Johann von Schreber, 1755

These pictures of bats, although somewhat stylised, are among the more realistic of the seven hundred or more handcoloured engravings (which verge on the surreal, if not the ridiculous, in some cases) in Johann von Schreber's multi-volume series from 1755, *Die Saugthiere in Abbildungen nach der Natur* (Illustrated Mammals from Nature). Von Schreber was a botanist and physician from Bavaria, who studied in Sweden with the father of taxonomy, Carl Linneaus. Consequently, many of the animals in these tomes were properly identified for the first time by the newly created dual scientific naming system. This may seem to add an air of legitimacy to the work, but collectively the series of illustrations is known as *Schreber's Fantastic Beasts* for good reason.

– – –

LYON NATIONAL SCHOOL OF VETERINARY SCIENCE
http://www.vet-lyon.fr/med/index.php

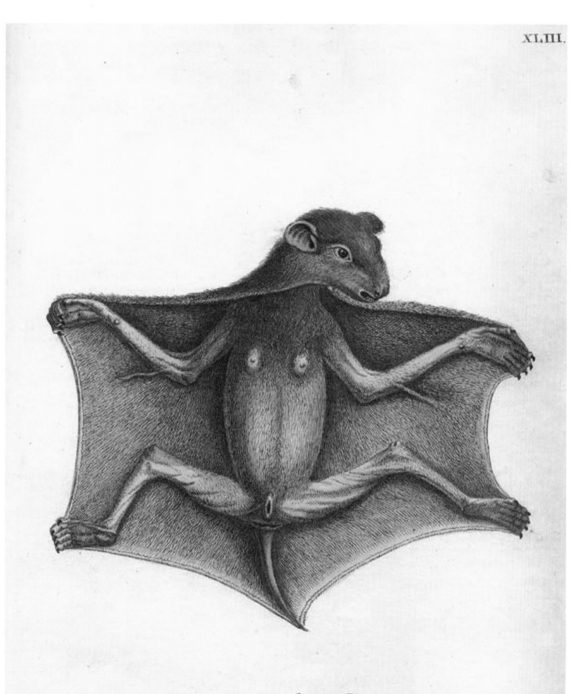

Lemur volans Linn.

Iof. Kellner sculps.

*L'Ècuyer Français qui Enseigne à Monter à Cheval
et à Voltiger*
Louis Imbotti de Beaumont, 1679

To meet the needs of the nobility who had a high regard
for horsemanship skills in 17th century France, Louis
Imbotti de Beaumont published the first illustrated manual
of trick riding in 1679. *L'Ècuyer Français qui Enseigne à
Monter à Cheval et à Voltiger* (The French Rider Teaches
How to Mount a Horse and Do Stunts) was said to have
been inspired by the lavish exposition on dressage and
horse training from a decade earlier by William Cavendish,
Duke of Newcastle. Wooden horses obviously allow
students to develop their acrobatic skills before attempting
manoeuvres with a real horse.

– – –

The Comic History of Rome
John Leech, 1852

Many ancient history students will be familiar with the parade of visual gags displayed in the 1852 classic, *The Comic History of Rome*. This was the second collaboration by two members of staff at the humorous *Punch Magazine*: Gilbert à Beckett and John Leech. Their first outing had similarly combined fact and satire in retelling the history of England. Beckett openly pitched the texts at people 'willing to acquire information [and] in doing so as much amusement as possible'. Leech was very much a contemporary of George Cruikshank, and another inheritor of the caricaturist mantle from the school of

Hogarth, Rowlandson and Gilray. His illustrative output for magazines and books (including Dickens) tended to be a little less severe and sarcastic than the work of his predecessors. The image here of Fulvia, the Roman political operative and third wife of Mark Antony, is one of a large number of amusing intertextual details dotted throughout the book.

– – –

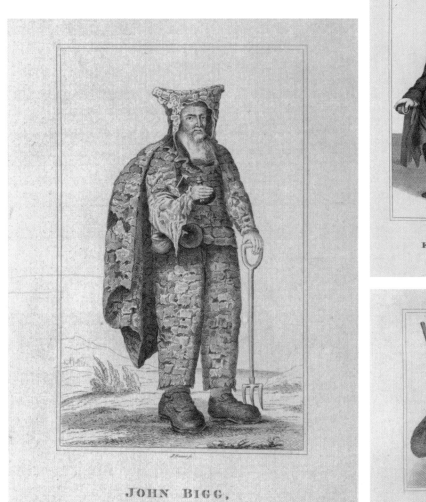

JOHN BIGG,

(The Dinton Hermit.)

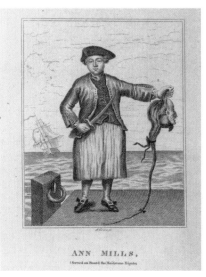

EDWARD BRIGHT,

(Of Malden in Essex.)

JOHN KEILING,

(alias Blind Jack.)

ANN MILLS,

(Served on Board the Maidstone Frigate.)

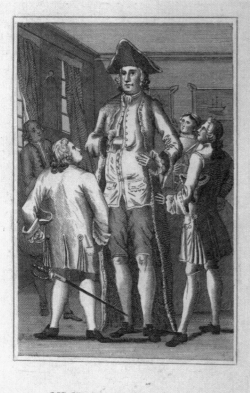

Mʀ HENRY BLACKER.

(The Irish Giant.)

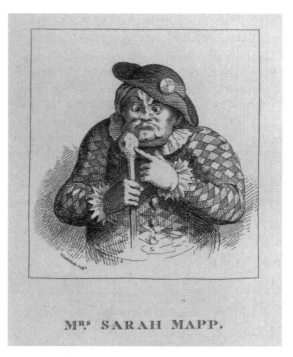

Mʀˢ SARAH MAPP.

Remarkable Persons
James Caulfield, 1820

With the 1820 publication of his four volume series, commonly known as *Remarkable Persons*, James Caulfield successfully tapped into the public's fascination with 'true stories' about notorious and eccentric types. Essentially, it is a collection of biographical sketches of people of physical extremes (corpulence, height, age, strength). It also shows other idiosynchratic characters like: Sarah Mapp, the wandering bonesetter; Blind Jack the nose flute player; Ann Mills, the female pirate, and an endless parade of charlatans, criminals and singularly notable freaks. Caulfield arranged for a team of engravers to prepare detailed illustrations of his unconventional characters from the 18th century, and he claimed to have undertaken extensive background research; but many of the sources would have been dubious at best. It's perhaps unsurprising that Dickens, who was unrivalled as a reporter of the peculiar tics and habits of the *other classes* of Victorian England in his novels, was known to possess a copy of *Remarkable Persons*. The images on display here are from a copy of the book originally owned by Queen Victoria at Windsor Castle.

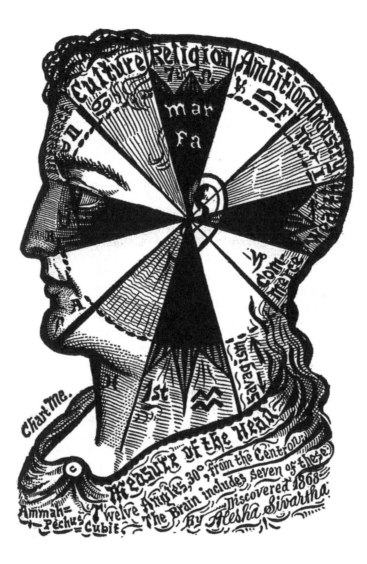

The Book of Life, 1898
The Growth of Man, 1903
Dr Alesha Sivartha

American mystic, Dr Alesha Sivartha, developed a belief system which asserted that modern scientific discoveries could aid society to achieve a spiritual harmony that had eluded the great cultures of history. Based in part on Darwinian evolution, Sivartha's eccentric theosophical teachings and pseudo-scientific illustrations were published in a couple of books at the end of the 19th century. His idiosyncratic views on brain structure and function, and their relationship to other areas of life are particularly odd. They were outlined in his series of brain maps in *The Book of Life* and *The Growth of Man* that wouldn't look at all out of place on 1960s concert posters.

– – –

COURTESY OF DON ROSS,
DR SIVARTHA'S GREAT GREAT GRANDSON
http://www.nichirenscoffeehouse.net/Sivartha

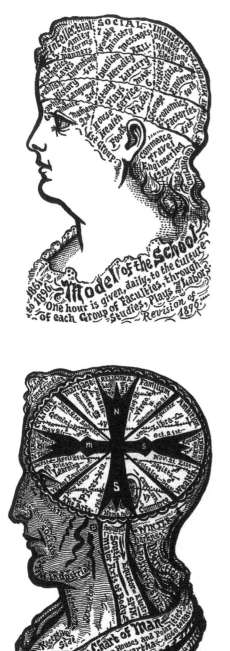

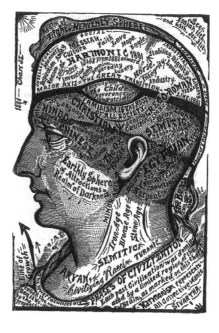

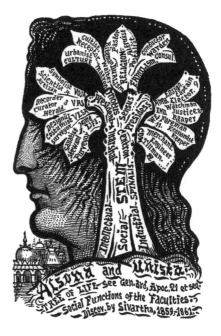

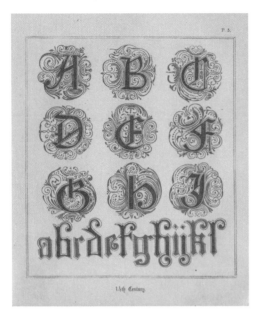

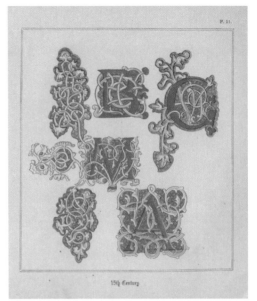

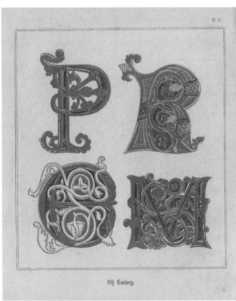

Medieval Alphabets and Initials for Illuminators
Freeman Gage Delamotte, 1886 (4th edition)

Freeman Gage Delamotte published a number of beautiful manuals on illuminated typography in the mid-19th century. In the preface to the present book, Delamotte seems to suggest that lettering techniques, particularly in the Georgian period, had suffered from disfiguring abstractions of the alphabetic forms and vulgar decorative embellishments. He hoped to influence the wider calligraphic arts community by providing a modest selection of classical illumination styles from manuscripts produced before the 16th century. In his other books, in addition to illuminated letters, Delamotte presented similar edifying examples of initials, monograms, ecclesiastical devices, emblems and ornamental borders as stylistic guides for embroiderers, masons, painters, engravers and related artisans.

– – –

ILLUMINATED BOOKS
http://www.illuminated-books.com

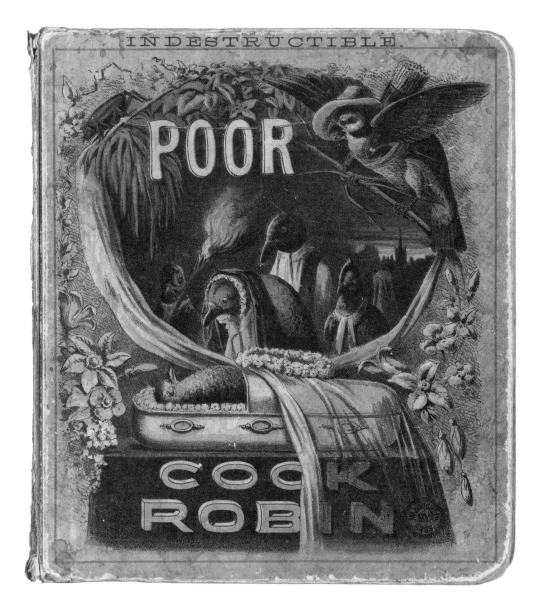

Published by McLoughlin Brothers
Anonymous, c.1880

'Who killed Cock Robin?' 'I', said the sparrow, 'with my bow and arrow'. The folk poem interrogation of a group of animals who line up to admit their roles in the death and funeral of Cock Robin was first published in *Tommy Thumb's Pretty Songbook* in 1744. Whether it is a satire about: Robin Hood; the first English Prime Minister Sir Robert Walpole's downfall (a contemporary event); Irish St Stephen's Day sacrificial rituals; or a borrowed remnant from Nordic mythology, remains a matter for conjecture. The curious lyrical format has been adapted and

embellished over the centuries to appear in many guises aimed at children, such as 18th century chapbooks and later fairy-tale compendiums. But various sophisticated adaptations of the murder/mystery and complicity/cooperation scenarios persist in modern adult literary, film and musical interpretations. The illustrator is not named but the McLoughlin Brothers in New York, were innovators with colour printing techniques for children's books – in this case, chromolithography – and their editions remain highly collectable today.

– – –

ILLUMINATED BOOKS
http://www.illuminated-books.com

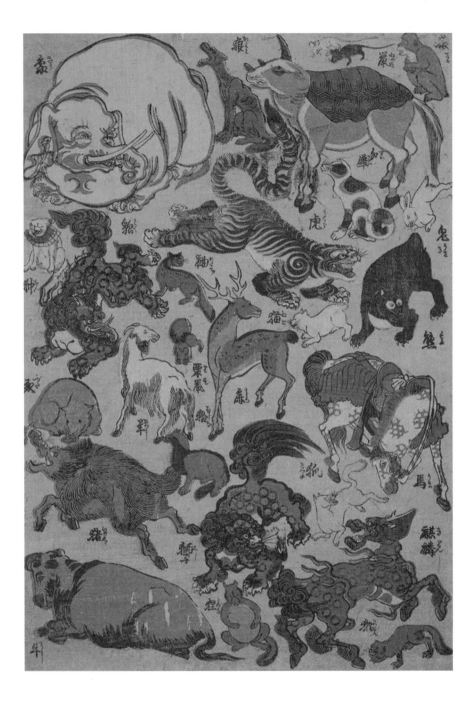

Shinpan Kedamono Tsukushi (New Illustration of Various Beasts), 1857
Shinpan Tori Tsukushi (New Illustration of Various Birds), 1852
Yoshiiku Utagawa

The Ukiyo-e (pictures of the floating world) artistic tradition began in the main urban centres of Japan in the early 17th century, reflecting the rise in economic power of the merchant and artisan classes under shogun rule. Typically, woodblock prints and paintings celebrated pleasure and entertainment, and depicted scenes and actors from kabuki and puppet theatres, beautiful courtesans and geisha, as well as more common amusements from everyday festivals and customs. Later, the genre broadened to include nature and landscape scenes and the woodblock colouring techniques (using up to sixteen individual blocks) became more sophisticated in the collaboration between publisher, artist, woodcutter and printer.

— — —

RARE BOOKS DATABASE, NATIONAL DIET LIBRARY OF JAPAN
http://rarebook.ndl.go.jp

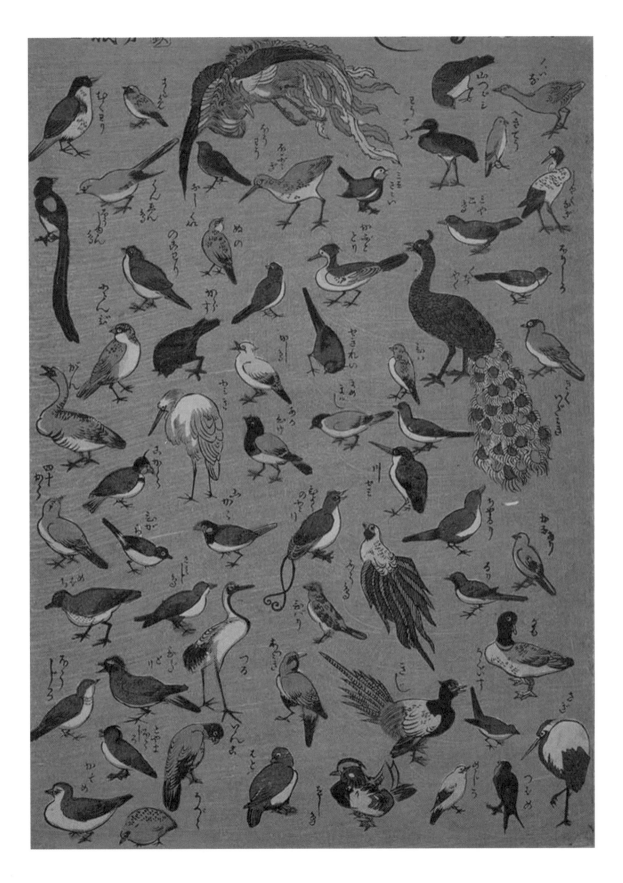

Dècouverte Australe par un Homme Volant,
ou Le Dèdale Français
Nicolas-Edmé Restif de la Bretonne, 1781

Depending upon your point of view, Nicolas-Edmé Restif de la Bretonne was either a socially progressive intellectual or something of a libertine reprobate. His prolific output ranged in nature from observations on the streets of Paris during the Revolution, to the first account of shoe fetishism, and various other anecdotes of perversion from his own life. One of his more curious (and very rare) publications, from 1781, was both a proto-science fiction book and a member of the utopian genre of literature. *Dècouverte Australe par un Homme Volant, ou Le Dèdale Français* (Southern Discovery by a Flying Man, or The French Dedalus) has the protagonist studying insects to help him build wings that take him to a kind of reverse

France, *Megapatagon* (Australia), on the other side of the world. There, the hero and his love create a new society where backwards french is the language and *Sirap* is the capital. During their flying expedition, they enounter a variety of human chimera species: pigmen, frogmen, hairymen, elephantmen and so on, which are recorded in the twenty-three engravings accompanying this decidedly odd text.

– – –

GALLICA DIGITAL COLLECTION,
NATIONAL LIBRARY OF FRANCE
http://gallica.bnf.fr

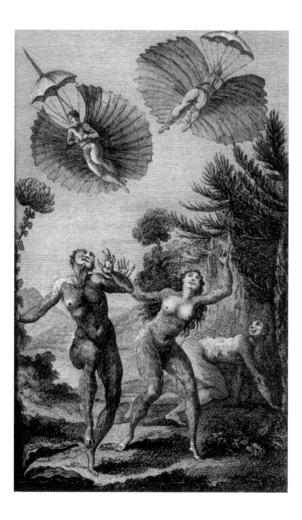

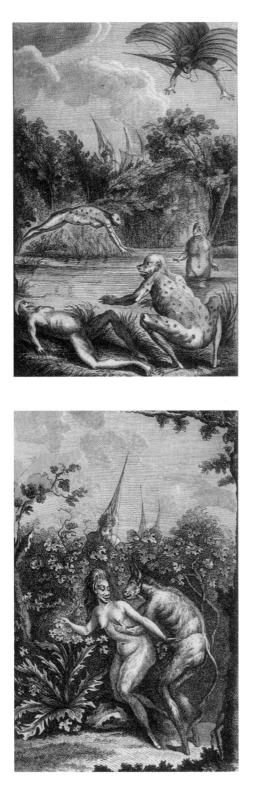

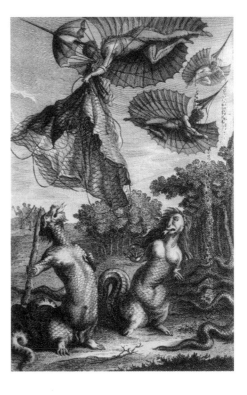

154

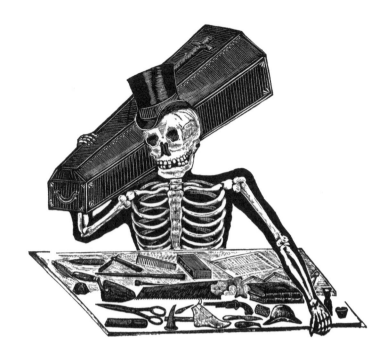

Los Calaveras
José Guadalupe Posada, 1852-1913

Mexican printmaker, José Guadalupe Posada, was an affable and humble artisan. He produced an estimated 20,000 lithographs and wood, zinc and type metal engravings during a forty-year career. His populist satirical, social and political illustrations graced broadsides for the penny press, newspapers, matchboxes, song sheets, magazines, games, books and advertisements – forming a visual catalogue of late 19th and early 20th century contemporary Mexican culture. Posada's enduring iconographic legacy are *Los Calaveras*, the humorous skeleton prints that draw upon influences from the both the *danse macabre* tradition of Europe and the annual Aztec-catholic-Mexican celebration of *Dìa de los Muertos* (Day of the Dead), to which the imagery is now closely connected. The mischievous skeletal caricatures gave Posada an iconic motif through which corrupt politicians, revolutionary leaders, heroes and common people could be mocked or glorified respectively.
(see also pages 80, 112)

– – –

COCONINO CLASSICS MUSEUM
http://www.coconino-classics.com

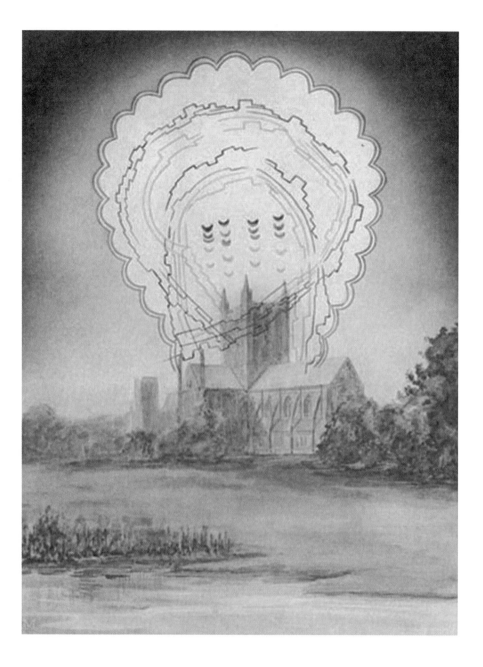

Mendelsshon and *Gounod*
Annie Besant and C.W. Leadbeater, 1901

Annie Besant was a prominent advocate in Britain for social reform and the advancement of women. Her intellectual development took her from Anglicanism to workers rights and strike organisation, through Fabianism and socialist politics, to birth control promotion, secularism, theosophy and home rule campaigning in India. She was a friend to the likes of Shaw, Krishnamurti and Gandhi and became both president of the Theosophy Society and the Indian National Congress party.

Her theosophical beliefs were influenced by a meeting with Madame Blavatsky and the present work – *Thought Forms* – was an attempt to depict 'the forms clothed in the living light of other worlds' and 'changes of colour in the cloud-like ovoid, or aura, that encompasses all living beings.'

– – –

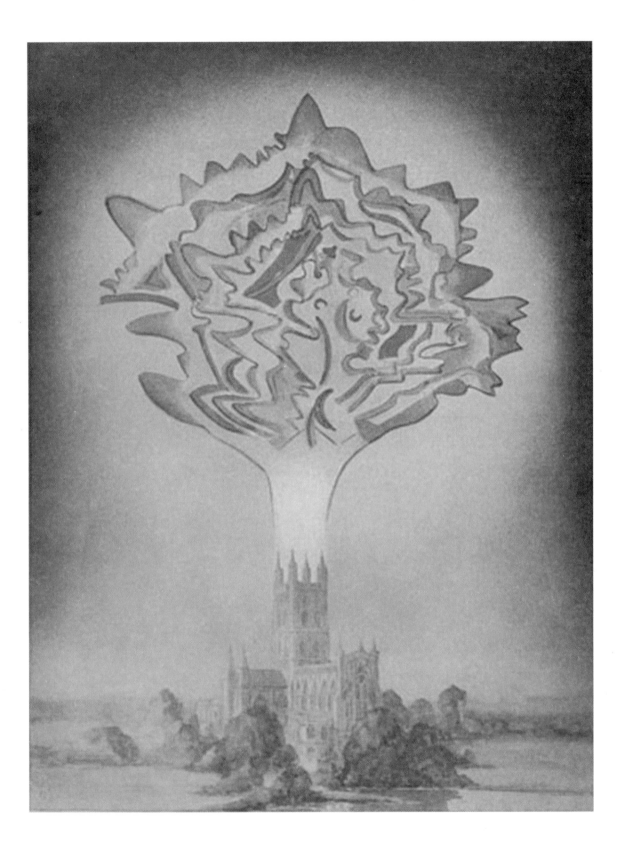

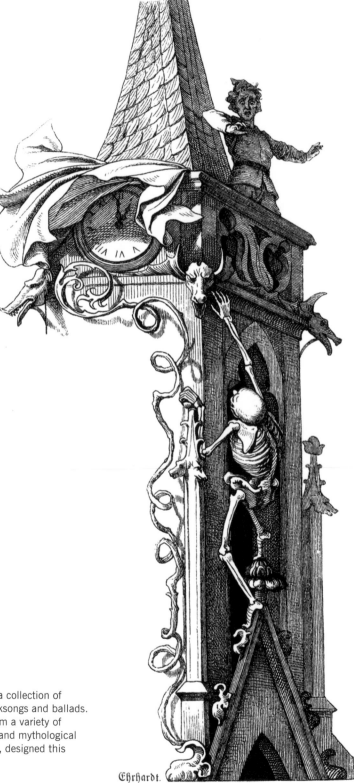

Deutsches Balladenbuch
Adolf Ehrhardt, 1852

The 1852 *Deutsches Balladenbuch* is a collection of
Medieval and Early Modern German folksongs and ballads.
Accompanying woodcut illustrations from a variety of
artists depict mainly cruasde, religious and mythological
scenes. German painter, Adolf Ehrhardt, designed this
one-off *danse macabre* sketch.

– – –

Page 4:

Introduction
Owen Jones, 1841

The Introduction arabesque comes from Jones'
outstanding illuminated 'gift book' (Ancient Spanish
Ballads) from 1841 in which his intricate border patterns,
half page vignettes and ornamental letters accompany
traditional verses.
– – –
ILLUMINATED BOOKS
http://www.illuminated-books.com

Page 7:

The Grammar of Ornament
Owen Jones, 1856

As Superintendent of Works for London's Great Exhibition
of 1851, Owen Jones will have been acutely aware of the
resulting criticisms leveled against a perceived tastelessness
and separation of form from function in the British design
aesthetic. By way of response, the architect and interior
design theorist drew upon his years of study in Turkey,
Sicily, Egypt, Greece and Spain, to create an outstanding
reference work on design, *The Grammar of Ornament*,
in 1856. The title is indicative of Jones' desire to give
credence to design principles over the decorative forms
themselves, and he included a manifesto of thirty-seven
propositions, or guidelines, to assist architects, illustrators
and craftsmen in 'the arrangment of form and colour'.
The book was no less significant and influential for its one
hundred sumptuous illustration plates of design motifs
from nineteen cultures. Jones had to establish his own
print works in order to create the stunning colour
illustrations, as no London printhouse was capable at
the time of employing the newly emerging technique of
chromolithography, which did away with the need for
hand colouring.
– – –
WALLACE LIBRARY, ROCHESTER INSTITUTE OF TECHNOLOGY,
THE RARE BOOK ROOM
http://rarebookroom.org

ACKNOWLEDGEMENTS

We would like to thank all the libraries and collectors who have given their
kind permission for the publication of their images.

The copyright remains with the copyright holders.

Text © PK, Dinos Chapman

Edited and designed by Murray & Sorrell FUEL

Other books published by FUEL

Notes from Russia
Alexei Plutser-Sarno
ISBN 978-0-9550061-7-3

Match Day • Football Programmes
Bob Stanley & Paul Kelly
ISBN 978-0-9550061-4-2

Ideas Have Legs
Ian McMillan Vs Andy Martin
ISBN 978-0-9550061-5-9

Home-Made • Contemporary Russian Folk Artifacts
Vladimir Arkhipov
ISBN 0-9550061-3-9

Russian Criminal Tattoo Encyclopaedia Volume II
Danzig Baldaev
ISBN 0-9550061-2-0

Fleur • Plant Portraits
Fleur Olby
ISBN 0-9550061-0-4

The Music Library
Jonny Trunk
ISBN 0-9550061-1-2

Russian Criminal Tattoo Encyclopaedia
Danzig Baldaev
ISBN 3-88243-920-3

For more information visit
http://www.fuel-design.com